DRAWING
WITH
Fire

A BEGINNER'S GUIDE

TO WOODBURNING
Beautiful Hand-Lettered
PROJECTS *and* OTHER EASY ARTWORK

≫ ANEY CARVER ≪
ARTIST AND CREATOR OF PYROCRAFTERS

PAGE STREET
PUBLISHING CO.

PAGE STREET
PUBLISHING CO.

First published in 2020 by
Page Street Publishing Co.
27 Congress Street, Suite 105
Salem, MA 01970
www.pagestreetpublishing.com

Distributed by Macmillan, sales in Canada by The Canadian Manda Group.

24 23 22 21 20 1 2 3 4 5

ISBN-13: 978-1-62414-957-3
ISBN-10: 1-62414-957-X

Library of Congress Control Number: 2019906545

Cover and book design by Aney Carver
Photography by Aney Carver

Printed and bound in China

For Clay,

MY BEST FRIEND, BIGGEST FAN
AND THE GREATEST PARTNER
ANYONE COULD ASK FOR.

CONTENTS

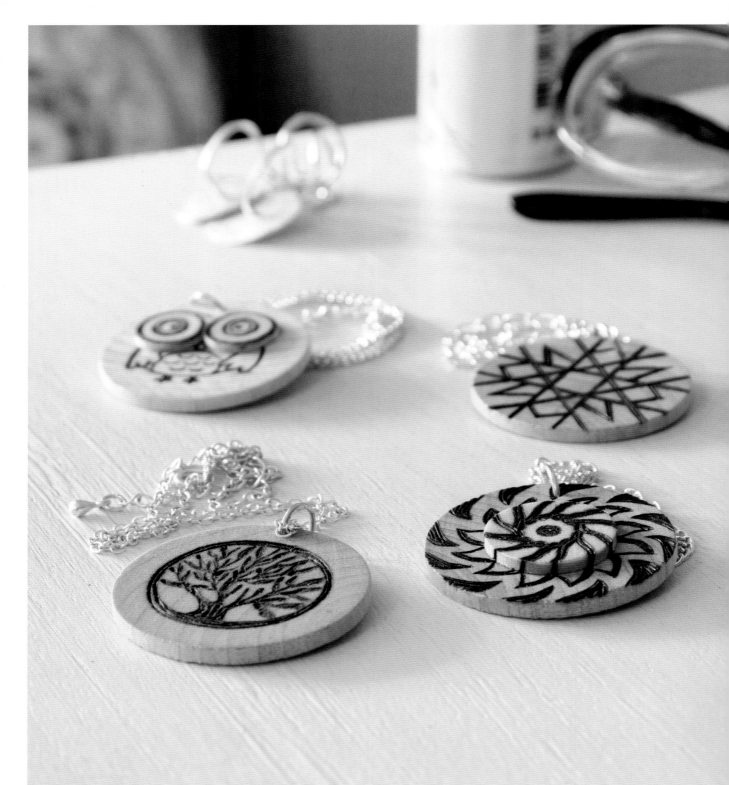

INTRODUCTION

Millions of people spend their spare time watching television day in and day out, and most feel unsatisfied. Why? I'm convinced that everyone is hardwired to create and be creative in their own way, despite how they may feel about their creative aptitude. It all starts with a moment of inspiration that encourages us to think, *I can do that; I can be creative!* Of course you can! Now, get up and let's do it. No more excuses about being unable to draw a stick figure or being too intimidated by others' talent to try something new. It's time to burn!

I'm asking you to take a leap of creative faith with me. Just think how fulfilling and satisfying it would be to turn your TV time into a productive hobby that involves making things with your own two hands. You are capable of creating unique pieces of art that you can be proud of and share with those you love. If you're ready to stoke those creative fires, then let's see what you can achieve.

I first became interested in pyrography after my husband bought a basic woodburning tool from Hobby Lobby to use in his woodworking. He came home and dabbled with it a bit, and one day I got the courage to swipe it from his shop and try my hand at burning an old business logo. In a half hour or so—boom—I had hand burned a pretty cool logo. It wasn't exactly perfect, but it did stoke my passion to create in a new and interesting way. Now, three years and hundreds of custom art pieces later, pyrography for me is still all about having fun and creating.

In this book, I'll share the what, when, where and how of pyrography. You'll get to create 19 different projects that will spark your confidence while improving your ability to burn. The early projects are simple lettering designs that will help you become familiar with woodburning tools, wood types, heat variables and best safety practices. The projects will become more complex as the book progresses, culminating in advanced shading techniques and landscapes.

You will experiment with different wood types, a variety of burner tips, burning different patterns, adding color and creating shading effects. Every project includes start-to-finish, step-by-step instructions and is accompanied by helpful images and illustrations.

I'm excited to introduce you to the endless possibilities of this art form.

Amy K Cum

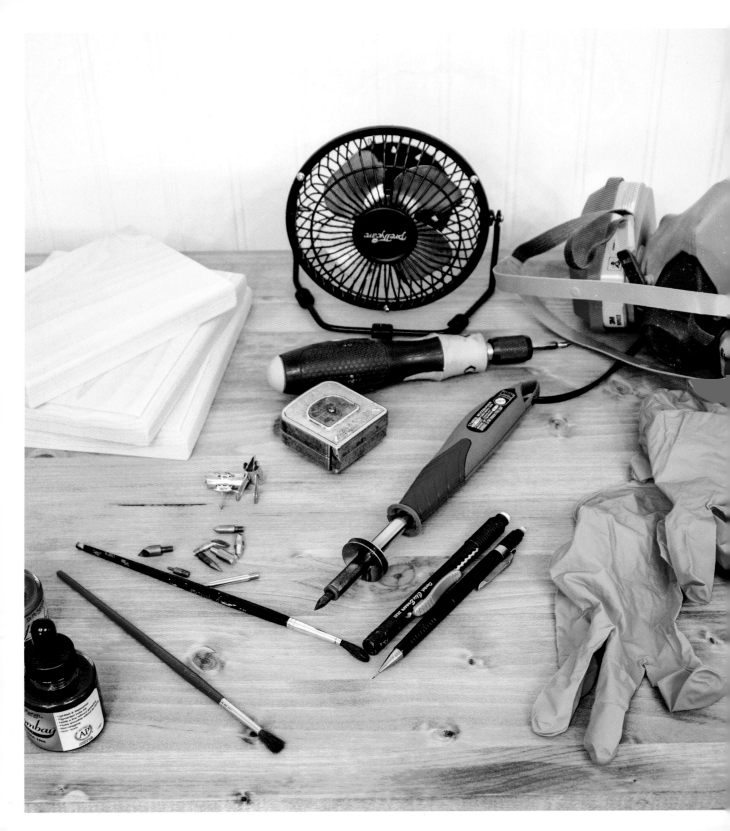

One

SETUP, SAFETY AND EQUIPMENT

I know you'd like to jump right in and start burning, but there are some things you need to know before you start. Woodburning is essentially using a glowing hot poker to sear an image into wood, so there are some obvious risks. However, having the right safety knowledge up front and a healthy respect for the tools will help minimize those risks.

Also, understanding the qualities of different wood types is important when you're choosing what to burn. Not all woods are ideal for every project, so knowing where to start is key. We're going to start with woods that have consistent grain patterns and are easily accessible. You can always experiment with other types, but for the purposes of this book, we are only going to cover a few options that you can pick up at your local arts and crafts store or online.

WOOD TYPES FOR BURNING

UNDERSTANDING THE GRAINS

There are some woods that are better for burning than others because of their grain pattern. For instance, pine has a distinct grain pattern that's a combination of soft and hard wood. The lighter grain is super soft, whereas the darker grain is hard. The inconsistency of the grain makes it more challenging to burn when you are trying to achieve fine details and straight lines.

Inconsistent grain patterns are not impossible to work with, though; you just need the right tips and heat settings to burn through them. It's common for beginners to struggle and assume they are doing something wrong or aren't good at burning, but they likely just need to use a different burner tip or heat setting. So, have no fear of those dreaded inconsistent grains. I'll show you how to burn right through them and create something beautiful.

In contrast, some woods, such as basswood and birch, have a very consistent soft grain that is perfect for burning. These types of wood have a consistent grain throughout, are lightly colored and are easy to source from various retailers. We will be burning basswood, birch and pine throughout the projects in this book. They are perfect for learning pyrography; however, as you gain experience with burning, I encourage you to research other woods and experiment with different options.

Pine

As mentioned earlier, pine can be a challenge for pyrographers because of its inconsistent grain pattern. The light grain is very soft and the darker grain is hard.

Your burner will typically cut through soft grain wood like butter and have a difficult time burning through harder dark grains. Since pine contains both hard and soft grains, the result can be an inconsistent burned look or bumpy scorched lines. However, don't despair—all you need to master burning pine is the right burner tip and a little practice.

Pine is the perfect wood to learn pyrography with for two reasons. First, it's cheap. You can visit your local arts and crafts store, hardware store or favorite online retailers to find a ton of pine wood canvas options in varying shapes and sizes. The availability and affordability of pine puts a great deal of projects at beginners' fingertips.

Second, understanding how to burn an inconsistent grain pattern will give you great experience with the heat settings of your burner. Once you get the hang of burning pine, you will quickly start to recognize how much heat you need and how to control the heat to achieve the look you want.

 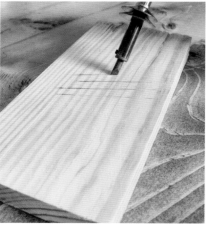 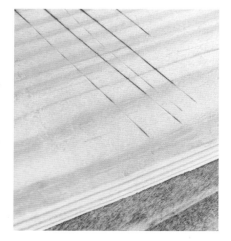

Pine wood grain patterns

Pine

Basswood

Birch

Basswood

Basswood is a great wood for burning because of its clean, consistent grain pattern that is super soft. It's an especially nice option for burning light or dark shading effects.

The only downside to basswood is that canvas-size options are limited; however, you can usually find live-edge canvases that add a woodsy touch to your overall finished piece.

Birch

Birch is another readily accessible wood option for burning. I typically find my birch canvases on Amazon. There are also several brands that carry birch panels in pine wood cradles.

Birch is similar to basswood in that the grain patterns are consistently smooth, which makes it a great option for burning detailed designs. Its visible wood grain can also add a nice finished look to your pieces.

OTHER WOOD OPTIONS

There are tons of wood options out there to try, but for beginners, pine, basswood and birch are ideal to start with. As you develop your woodburning skills, here are a few more types of wood to consider.

Poplar

At Pyrocrafters, we typically make our canvases in the woodshop using poplar, which has a soft and consistent grain. Poplar also has a nice light color that allows for a lot of shading detail. You will almost certainly have to make your own canvas if you want to work with poplar because premade canvases aren't available to purchase online. You should also know that poplar is pricier than the other wood options I've recommended thus far, and it's sensitive to humidity and moisture, so you'll need to seal your finished piece.

Red Oak

Although it's a costly, heavy wood that's typically used in furniture building, occasionally we will use reclaimed red oak for an art or décor project. Its beautiful red hue contrasts wonderfully with black walnut and works well for keepsake boxes. However, red oak isn't the easiest wood to work with. It has a hard grain that's difficult to burn, and it's typically not available for purchase at craft stores. If you ever consider red oak for a special project, make some test burns on scrap pieces before investing in a canvas.

As you become more experienced with pyrography, I encourage you to research and experiment with other wood and canvas options to find what you like to burn as an artist. You may be limited in the types of materials you can work with if you don't have access to heavy-duty equipment like table saws and miter saws, but get creative! There are so many possibilities to explore.

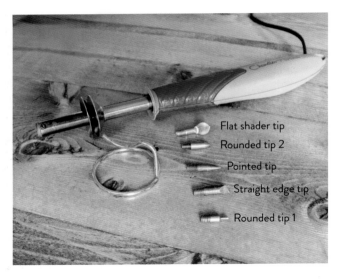

Flat shader tip
Rounded tip 2
Pointed tip
Straight edge tip
Rounded tip 1

WOODBURNING EQUIPMENT

CRAFT BURNERS

A craft burner is an inexpensive woodburning tool you can pick up at your local craft store. They typically range from $10 to $40 and have screw-in metal tips with limited heating options. These burners are great to start practicing pyrography with because they can burn anything the pro burners can. Using a craft burner just takes more time and offers fewer features.

Craft burners take a while to heat up and cool down. It's important to let the burner tip cool completely before unscrewing it and adding a different tip. If it's too hot, you risk stripping the screw threads that hold the tip in place. Learn from my mistakes: wait for the tip to cool. I've destroyed a couple of starter burners by being impatient.

Once you've gotten comfortable using a craft burner on some different wood types, you can upgrade to a pro burner with more features.

We will be using a starter burner throughout the book in every project. For tips, we will be using a straight edge tip, round tip 1, round tip 2, flat shading tip and pointed tip.

PRO BURNERS

Professional burners offer more options for the experienced pyrographer. They heat and cool quickly and have replaceable prong tips, more powerful heat settings and a larger tip variety.

As you become more comfortable burning and want to take your skills to the next level, try a professional woodburning kit. There are several trusted manufacturers out there that make great equipment. Every pyrographer has their preference, so do a little research on the tool that will work best for you.

My personal favorite is the Colwood brand. I've been burning with it for several years. The wands that hold the tips come in a fixed tip or replaceable tip option. I love the replaceable tips because they can be switched out quickly. Because craft burners have tips that are screwed in, you have to wait for them to cool and wait for them to reheat every time you want to change a tip. However, the pro burners heat and cool within seconds, and the tips are on prongs rather than screws, so they slide in and out of the wand very quickly. This makes switching tips so much easier when you are a working on a project that requires multiple tips.

Colwood also offers a large variety of tip options, burner models and accessories for woodburning.

PREPPING THE WOOD

Before burning any premade canvases, you'll want to lightly sand the surface with a fine grit sandpaper to smooth it out. Premade canvases typically have been handled quite a bit and need a quick sanding. Basswood in particular will have a dusty layer of wood buildup, and your burner will glide across the wood better when it's had a fresh sanding.

TRANSFERRING YOUR TEMPLATES

In Chapter Seven (page 138), you'll find premade templates that correspond to all the projects in this book. Each one can be cut out (or scanned and printed if you want to keep an original). Let's quickly walk through the process you'll use to transfer the template designs for each project.

Gather some tape and erasable carbon paper. Place the template on the wood surface you'll be burning, design-side up. Once you have it in place, tape it down on one side only. Slip your carbon paper underneath the template, carbon-side facing the wood, and begin to trace the template with a pencil (see photo 1). Have an eraser nearby just in case a mark is made accidentally (see photo 2).

It's really convenient to work with an erasable carbon paper if you make a mistake while transferring a design. The only way to remove regular carbon paper marks is with fine grit sandpaper.

Once you're done tracing the design, lift the carbon and template to do a quick check that you've traced all the lines (see photo 3). If you've missed any, trace them and then remove the template and carbon paper.

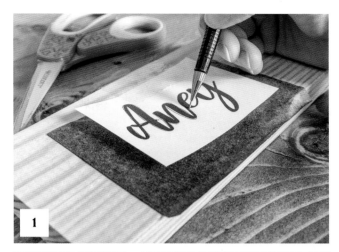

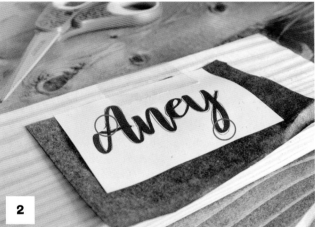

Tip

Don't worry about tracing the template perfectly. Small edge errors can easily be corrected once you start burning.

ALTERNATIVE TRANSFER METHOD

If you don't have access to carbon paper, another easy method for transferring templates—especially smaller ones—requires just a pencil.

(continued)

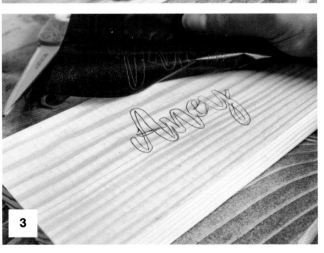

Once you've pulled and trimmed your template, flip it over to the blank side. Use your pencil to scribble all over the back of the template. You are creating a transferrable carbon for tracing the pattern onto the wood. Once you've completely covered the back of the template in pencil, flip it over so the design is facing up, position it on your canvas and secure it in place with tape.

Begin tracing the design with your pencil. The scribbled pencil on the back of the template will transfer to the wood, leaving an outline of the design. Once you've finished, remove the template and make sure you didn't miss any lines.

Varnishing a finished piece with Danish oil

PROTECTING YOUR PIECES

Without proper protection, wood is susceptible to UV rays, moisture and time in general. All of these elements can affect the appearance of woodburned pieces, even in indoor environments. That's why it's important to be proactive about protecting your art pieces as soon as you complete them.

AVOIDING FADING

The topic of fading has long been discussed by pyrographers the world over, and everyone has different opinions about the subject. The fact is, wood color changes over time—some varieties more than others—and your woodburnings may fade if they aren't protected properly. This is especially true if you burn really lightly. However, there are things you can do up front to slow the process.

First, consider where your woodburned item will be displayed. For example, if you are making a sign that will be hung outside, you'll want to burn the art as dark as you can get it and consider using a heavy-duty varnish or oil that has a UV protectorate to prevent moisture damage and fading from direct sunlight. Spar Urethane by Minwax is a great option for outdoor projects. You can also reapply the varnish later to keep the UV protectorate fresh.

If you're creating a piece of art that will be hung inside a home, you can use less heat to achieve finer, lighter details, but applying a varnish or oil that will protect

against warping and fading is still recommended. Even indoors, UV rays can change the look of woodburned pieces over time. If the piece is hung next to a UV light or in direct sunlight, it will speed up the process of the wood changing color.

VARNISHES AND OILS

There are a variety of varnishes and oils to choose from to protect your pieces.

Danish oil is my varnish of choice for indoor pieces of artwork. It soaks into the wood, giving it a nice coat of protection. It has a matte finish, so there's no shiny glare, and it also goes on very easily without streaking. A couple of coats will help prevent moisture damage. I always use a natural version that's untinted, but the oil does still darken the wood slightly.

Polyurethane is another popular choice. It's a heavier varnish, but it can be tricky to work with. Some polys will leave streaks if you don't follow a certain application method. Wipe-on poly is a good alternative to traditional polyurethanes because it's easier to apply. As mentioned earlier, I use a heavy-duty polyurethane varnish with UV protection when I make a piece for outdoors. Spar Urethane by Minwax is a great option that will stand up against the elements and protect against sun, rain and moisture damage.

Acrylic varnish is also a really popular choice with a lot of pyrographers. It will not yellow or discolor the wood, it works great with added color/paints and some varieties offer UV protection.

You may even want to try a spray-on varnish. They are easy to apply, but they may not go on as smoothly or evenly as brush-on varieties.

For most of the projects in this book, I recommend using a Danish oil with a sponge brush for application. However, you can use any varnish you feel comfortable using. Just make sure to do some research about applying it to wood beforehand. Perhaps try testing it on a scrap piece of wood first.

SAFETY

Safety is an important aspect of woodburning. There are several preventative measures you can take to keep yourself safe from finger burns, unsafe canvas materials and smoke inhalation.

MASKS

I wear a respirator mask with filters that are designed to protect against organic vapors. It is a bit inconvenient, but it's a necessary precaution, especially if you are going to be burning often. The masks will prevent smoke inhalation and keep you from breathing in too much smoke over long periods of time.

FANS

Fans are another great way to help minimize smoke exposure while you're woodburning. I keep a small desk fan near my burning area to pull the smoke away from my face. When I'm indoors, I place another fan in a nearby window to pull the smoke outside. This strategy helps keep smoke from building up in an indoor workspace. A fan is also good to have nearby if you need to quickly cool off the tip of your burner to achieve a lighter burn.

WOOD TYPES TO AVOID

Knowing what not to burn is as important as knowing what you should burn. Medium-density fiberboard, or MDF, is a tempting material to burn because it is cheap and readily available. However, I highly recommend leaving it alone when it comes to pyrography. It has been glued up and mashed down with all sorts of chemicals, and it's not safe to burn.

Pallet wood is another woodburning temptation. They are made of all types of wood, including white pine, oak, poplar and yellow pine, to name a few. They're usually easy to find for free. If you can somehow get a guarantee that the pallet wood hasn't been treated with dangerous chemicals, then go for it. If you can't get that guarantee, don't risk it. Pallets are used to transport all sorts of items around the world, and it would be extremely difficult to figure out the origins of any given pallet. It isn't worth your health, and it is a pain in the you-know-what to take apart, sand down and prepare a pallet for woodburning. I don't recommend it. There are plenty of other safe, affordable woodburning options out there.

FINGER GUARDS

Finger guards were hard to find when I first started burning, so I made my own with a leather garden glove. I put on the glove, wrapped my thumb, index finger and middle finger with duct tape and then cut the tips off. They worked fine for a while, but after hours of burning, the tape seemed to conduct heat. Plus, they were very bulky and tended to get in the way when I made videos and took pictures.

It wasn't that long ago that I found silicone finger guards online. They work nicely and are much easier to take on and off than my homemade ones. However, the best finger guards I've used to date were designed to protect against burns from hot hair styling tools such as curling irons. The tips are heat resistant and are cut already. You just slip them on and off when needed. You can find them online. I purchased my set through Amazon.

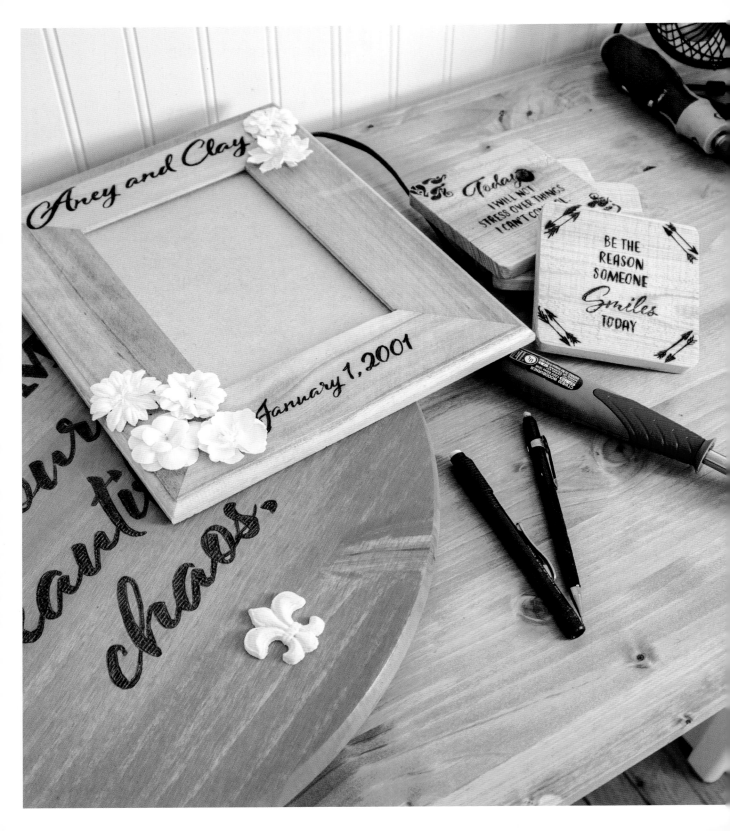

Two

BEAUTIFUL LETTERED ART

Lettering projects are wildly popular and a great way to get started with woodburning. You can experiment with different fonts, textures, shapes and tips to make pieces that are both functional and beautiful. The Welcome Sign project (page 19) is just one great example from this chapter. The goal in this chapter is to create beautiful signs and objects for your home while getting some woodburning practice.

These step-by-step projects were specifically designed to ease first-time pyrographers into woodburning. You'll learn how to confidently use a woodburning tool and gain some practice using it on a few different wood types as you outline letters, experiment with texture and add some extra flourishes.

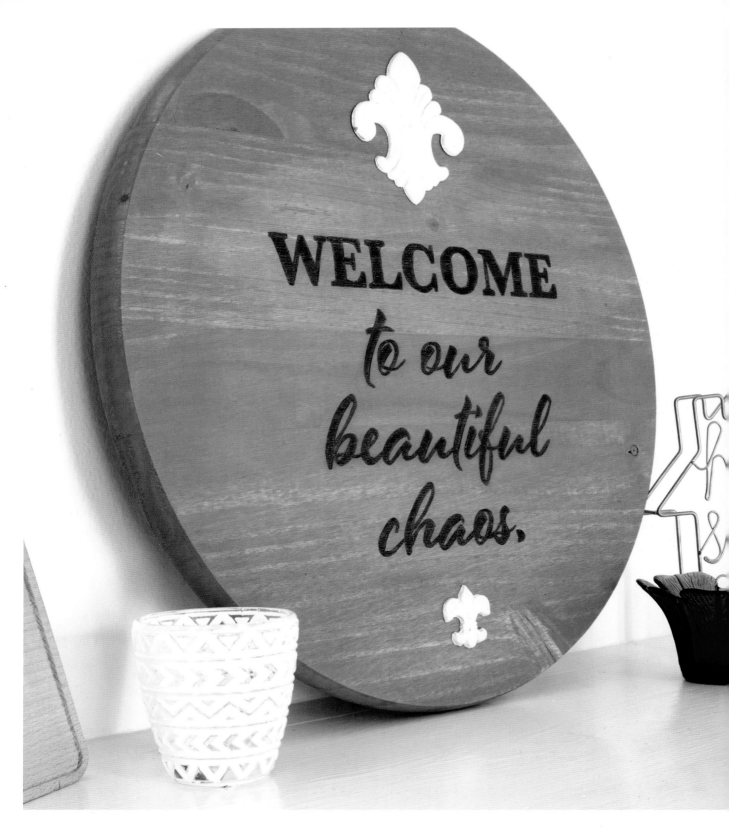

WELCOME *Sign*

This simple project is intended to help you get familiar with your woodburning tool, its heat settings and how the wood feels when you burn it. You'll be working with pine in this project, which you may recall has an inconsistent hard and soft grain. As you are burning, you will notice how easy it is to burn too deep in the soft grains and how challenging it is to achieve the same degree of darkness on the hard grains. You'll have to adjust the heat settings on your burner or change how quickly you burn if you're using a burner without heat settings.

I encourage you to take your time and experiment with the burner. You can't go wrong with this project. Your main goal here is to learn about your burner and what the wood feels like when you're burning. This is your introduction to pyrography, so have fun and don't worry too much about making a perfect finished piece.

Lettering signs are extremely versatile. You can create custom signs for your home, gifts for a loved one and funny sayings to hang up in the bathroom.

ABOUT THE WOOD

For this lettering project, we will only be burning letters in a deep dark burn, without shading. A wood like pine is a great option. The inconsistencies in the grain pattern won't interfere with the lettering lines, and larger pine canvases are affordable and easy to find.

WHAT YOU'LL NEED

- Woodburning tool with a straight edge tip and a round tip 2
- Safety equipment: mask, fan and finger guards
- Template (see page 140)
- 18" (46-cm) round pine canvas (I got mine from The Home Depot)
- Erasable carbon paper
- Pencil
- Tape
- Weathered Gray stain by Varathane
- Craft paper or cardboard to protect your workspace (optional)
- Gloves
- 2 sponge brushes
- Wood accent flourishes (I got mine from Hobby Lobby)
- White or cream acrylic craft paint
- Medium paintbrush
- Spar Urethane by Minwax
- Wood glue
- Sawtooth hanger with screws
- Phillips head screwdriver

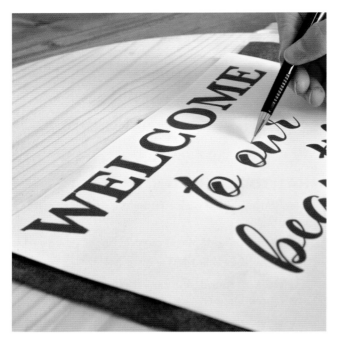

STEP ONE: SETTING UP AND TRANSFERRING THE ARTWORK

» Put a straight edge tip in your burner. Turn on your burner to medium-high and let it preheat while you set up your canvas in your workspace. You will be burning big lines in this project, so you can turn up the heat more if you want to burn at a faster pace.

» You can still make this project even if your burner doesn't have heat settings. The default heat setting should be appropriate for burning faster and larger lines and shouldn't overpower the wood, but if your tip is too hot, you can always hold it in front of your fan for a few seconds to cool it off.

» As we discussed in Chapter One, safety equipment is important. Have your mask, fan and finger guards nearby and ready to go.

» Pull the template on page 140. Transfer the template onto the wood using the carbon paper, pencil and tape. Refer to the Transferring Your Templates section in Chapter One (page 13) for details. Make sure to leave enough room for the top and bottom of the lettering to add your accent flourishes. Once you've finished, remove the template and carbon paper, and make sure you didn't miss any lines.

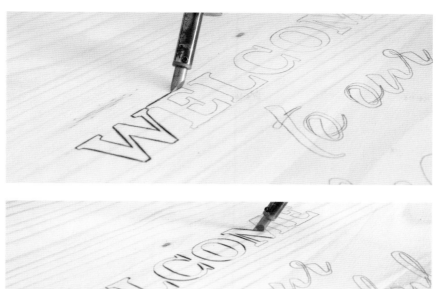

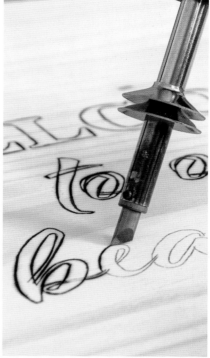

STEP TWO: OUTLINING THE LETTERS

Tip

I've found that pine wood has a lot of give and burns quickly, so you need to burn at a fast pace in order to prevent scorching the wood or creating a deep dark burn where you don't want it.

» Now that your burner is nice and hot, you can burn all the outlines of the letters. Outlining the letters first makes it easier to fill them in later, and it gives the letters a nice crisp, clean edge.

» Follow the carbon lines on the wood until the outline of every letter is burned.

» When you are burning the curves of the letters, go at a steady pace and try to keep your hand still as you guide the burner. It's easy to get comfortable with the straight lines, go too fast and then burn too far outside of the edges of the design.

» After you've completed all of the outlining, turn off your burner and let it cool. Switch the tip to the round tip 2. Turn your burner back on and let it heat up to a medium heat level.

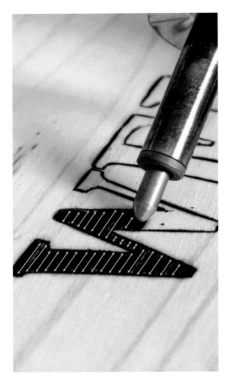

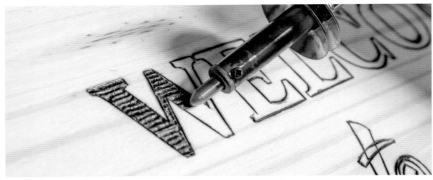

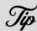

Tip

If you accidentally burn outside the lines, it's okay, you can fix it. Once you finish the inside pattern, switch back to the straight edge tip. Using the straight edge, trace along the existing outer lines, adding more lines to cover up the spots.

STEP THREE: FILLING IN THE LETTERS

» Now that the letter outlines are all burned, fill them in with a straight-line pattern. I love this pattern because it adds a nice texture to the letters instead of just a flat solid burn.

» Let's start with the letter W. You are going to burn straight horizontal lines inside each letter.

» Place the tip of the burner inside the left edge of the W and drag it across the wood's surface to the right side of the letter's edge. This creates a straight horizontal line. Place the tip of the burner just below the first horizontal line and drag it across to the right side again. The goal is for the burned lines to touch so that the whole surface is burned. Repeat this process until you have filled in the entire letter with straight horizontal lines.

» Continue burning inside all of the letters until they are completely filled in.

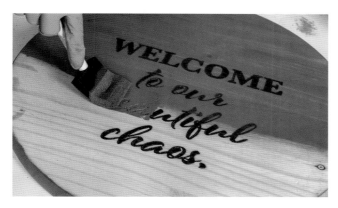

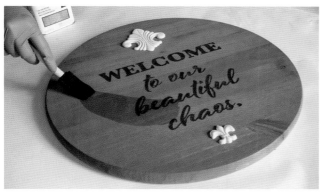

STEP FOUR: STAINING, PAINTING AND VARNISHING

Staining

» Before adding the wood accents, you are going to stain the wood sign with the Weathered Gray stain by Varathane. The soft grains will really soak in the stain while the hard grains will resist it just a bit. The contrast adds such a rich finish to the piece, giving the wood an old weathered farmhouse look.

» Spread your craft paper or cardboard over the surface you're working on. Put on your gloves, grab a sponge brush and load it with stain. Follow the grain of the wood as you apply the stain, covering your piece completely on both sides. Allow the stain to dry according to the manufacturer's directions.

Painting

» While your sign is drying, you can paint the small wooden accent pieces. Grab your white or cream acrylic craft paint and your paintbrush. Load your brush with paint and paint the front side of your accent pieces. Allow them to dry before flipping them over and painting the back. Let them completely dry before varnishing.

Varnishing

» Grab your gloves, another sponge brush and the Spar Urethane. Read the directions about ventilation and recommended drying times before using it. Spar Urethane by Minwax is pretty strong stuff. Load the sponge brush with varnish and coat your sign front and back. Don't forget to varnish the accent pieces. Allow the varnish to dry according to the manufacturer's directions.

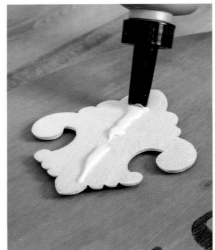

Tip

If you can't find the same wood flourishes I used, feel free to improvise and use decorations that suit your décor or are more to your liking. A large flourish at the top and small flourish at the bottom rounds out the sign and balances the artwork.

STEP FIVE: ADDING THE ACCENTS AND HANGING THE SIGN

» Try positioning your painted accent pieces around the sign to get an idea of exactly where you want to glue them. I opted to decorate the top and bottom of the sign with my accent pieces. Once you have the placement figured out, glue the accents in place. Let them dry.

» Grab your sawtooth hanger to attach to the back of the sign. Make sure the hanger you use has the capacity to hold the sign. The one I used was rated to hold 25 pounds (11 kg). Center the sawtooth hanger on the back of the sign and secure it in place with screws.

INSPIRATIONAL *Coasters*

The small wooden canvases you need for this project are readily available at local craft stores and are the perfect size for new pyrographers to tackle. It's easy to transfer the artwork onto them, and they make for quick woodburning projects. Burning the small details can be challenging, but using the right burner tip makes a huge difference in your results.

Inspirational quotes are a popular option to incorporate into décor pieces. I have several of my favorites hanging on my vision board to help me stay motivated and focused on my goals. For these coasters I chose four quotes that are particularly meaningful to me. I hope they resonate with you and serve as a reminder of your goals and the beginning of your pyrography journey.

ABOUT THE WOOD

Think about the style of the décor that will surround your coasters before choosing the canvases to make them. I chose simple square-cut pine coasters. These particular canvases have a rough-sawn surface that needed to be sanded before burning so it wouldn't interfere with adding the small letter details. Sanding the surface of your coasters with a fine grit sandpaper is recommended, regardless of whether they're rough-sawn or not. The design template will transfer more easily onto a freshly sanded surface and the designs will burn more smoothly.

WHAT YOU'LL NEED

- Woodburning tool with a straight edge tip and a pointed tip
- Safety equipment: mask, fan and finger guards
- Templates (see page 141)
- Scissors
- Square wooden coasters (you can find these in your local arts and crafts store or online)
- Carbon paper
- Pencil
- Tape
- Gloves
- Sponge brush
- Danish oil
- Craft paper or cardboard to protect your workspace (optional)

Today,
I WILL NOT
STRESS OVER TH...

smiles
TODAY

BE
Stronger
THAN YOUR
EXCUSES

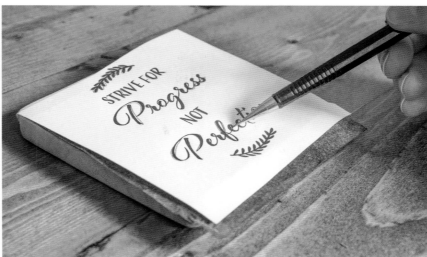

Tip

Try to find coasters that don't have holes or dark wood knots.

STEP ONE: SETTING UP AND TRANSFERRING THE ARTWORK

» Put a straight edge tip in your burner. Turn on your burner to medium and let it preheat while you set up your canvas in your workspace. You will be burning small lines in this project, and working with less heat will allow you to work at a slower pace and control the burner more easily.

» If your burner doesn't have heat settings, the default heat setting is likely too hot to achieve the best results. However, you can use your fan to temporarily cool the tip of the burner so it doesn't scorch your wood. You may have to place the tip in front of your fan several times throughout the burning process, especially when you're burning some of the smaller lines.

» As we discussed in Chapter One, safety equipment is important. Have your mask, fan and finger guards nearby and ready to go.

» Pull the templates on page 141 and cut them down to size. Transfer the templates onto the wood using the carbon paper, pencil and tape. Refer to the Transferring Your Templates section in Chapter One (page 13) for details. Once you've finished, remove the templates and carbon paper, and make sure you didn't miss any lines.

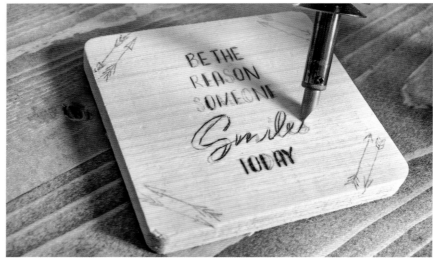

STEP TWO: BURNING THE STRAIGHT EDGES OF THE LETTERS

» Now that your burner is nice and hot, begin by burning all the lines that have a straight shape. Even the curved letters have some areas that are straight shapes. T, L and E are a few examples that have long straight lines. This is great way to work through all of your letters quickly, and using the straight edge tip doesn't require a lot of technique.

» You can also assess the designs on each coaster and burn any designs that have straight lines, like the arrows and branches. This will prevent you from having to change tips more than once.

» Complete this step on each coaster. Once you've burned all the straight lines, turn off your burner and let it cool down.

» Once the burner is completely cool, change the tip to a pointed tip. This tip will allow you to burn the curves of the letters. Turn the burner back on and let it heat up to low heat.

STEP THREE: BURNING THE CURVES OF THE LETTERS AND VARNISHING

» When your burner is hot again, burn the curved lines in each letter. The pointed tip will let you move along the curved portions of the carbon transfer lines more easily and burn the harder, smaller spaces with more control.

» The drawback to using the pointed tip is that you are more susceptible to bumpy edges, but that's okay. No burn is ever going to be totally perfect, and you can always go back and clean up any edges that stick out.

» Burn all the curved letters and designs on all four coasters.

» Grab your gloves, sponge brush and Danish oil. A few coats of Danish oil will protect the coasters from moisture damage and help them last longer. If you are varnishing the coasters in an area that you want to protect from drips and spills, put down a couple layers of craft paper or cardboard for protection.

» Pour a small amount of the Danish oil over one coaster at a time and use the sponge brush to spread it all over, front and back. Allow the varnish to dry according to the manufacturer's directions. Once the coasters are dry, apply a second coat of Danish oil for added protection.

» Set the coasters out to enjoy or give them as gifts.

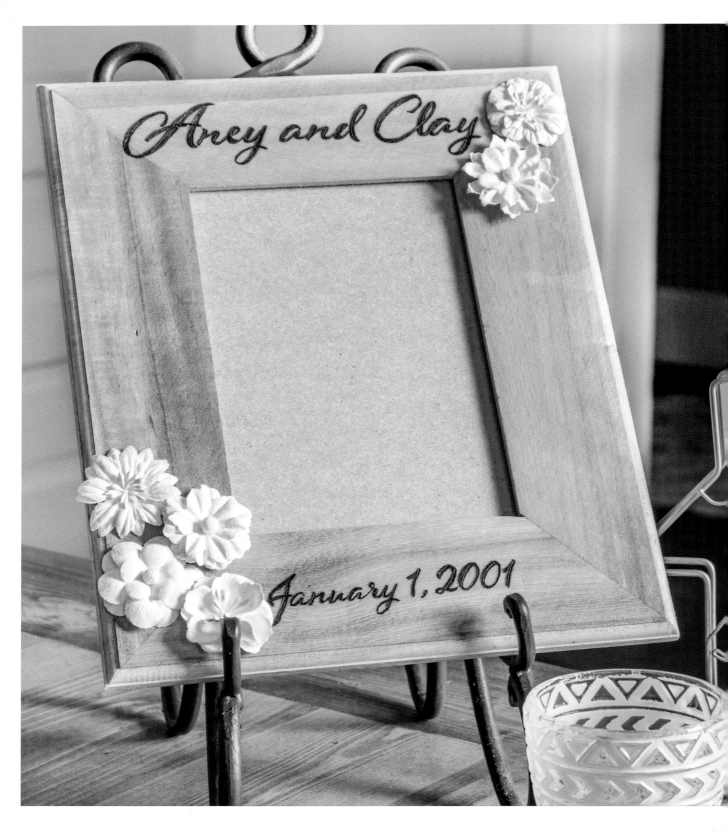

WEDDING GIFT
Picture Frames

Personalized, handcrafted keepsakes make excellent wedding gifts. And who doesn't love a nice picture frame? The goal for this project is simple elegance: a beautiful wood frame, custom woodburning and white paper flower accents.

The challenge will be creating the customized template you'll use to personalize the frame. Chapter Seven (page 138) includes instructions to create your own template, but if you don't have access to a computer and printer, you can use the font templates on page 151 to put together the names and date you need for customization.

ABOUT THE WOOD

For this project, the frame needs to be simple, elegant and wide to fit your recipients' names and wedding date. I went with a pine canvas that has 2½ inches (6.5 cm) of space on all four sides. Choosing a simple frame without any routing or shaping will ensure that it won't distract from the main attraction—the photo your recipients decide to display in it.

WHAT YOU'LL NEED

- Woodburning tool with a straight edge tip
- Safety equipment: mask, fan and finger guards
- Templates (see page 151)
- Scissors
- Tape
- 9" x 11" (23 x 28–cm) wood frame with 5" x 7" (13 x 18–cm) center pic, glass and backer
- Carbon paper
- Pencil
- Gloves
- Sponge brush
- Danish oil
- Craft paper or cardboard to protect your workspace (optional)
- Decorative paper flowers (I got mine at Michaels)
- Wood glue

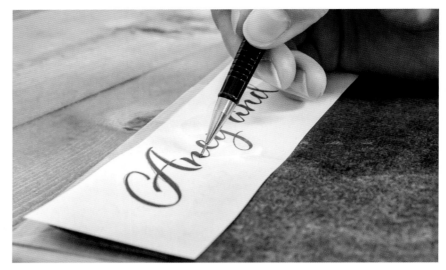

STEP ONE: SETTING UP AND TRANSFERRING THE ARTWORK

» Put a straight edge tip in your burner. Turn on your burner to low-medium and let it preheat while you set up your canvas in your workspace. You will be burning small letters in this project, and the tip will scorch the frame if it gets too hot.

» If your burner doesn't have heat settings, the default heat setting is likely too hot to achieve the best results. However, you can use your fan to temporarily cool the tip of the burner so it doesn't scorch your wood. You may have to place the tip in front of your fan several times throughout the burning process, especially when you're burning some of the smaller lines.

» As we discussed in Chapter One, safety equipment is important. Have your mask, fan and finger guards nearby and ready to go.

» Because you are personalizing this frame, you'll either have to make your own template on the computer following the instructions in Chapter Seven (page 138) or piece together a template using the lettering templates on page 151. If you'll be doing the latter, cut out the individual letters and numbers you need and tape them together to create a personalized template.

» Transfer the template onto the wood using the carbon paper, pencil and tape. Refer to the Transferring Your Templates section in Chapter One (page 13) for details. Once you've finished, remove the template and carbon paper, and make sure you didn't miss any lines.

STEP TWO: BURNING THE LETTERS

» Now that your burner is nice and hot, you can burn all the outlines of the letters. Outlining the letters first makes it easier to fill them in later, and it gives the letters a nice crisp, clean edge. Follow the carbon lines on the wood until the outline of every letter is burned.

» When you are burning the curves of the letters, go at a steady pace and try to keep your hand still as you guide the burner. It's easy to get comfortable with the straight lines, go too fast and then burn too far outside of the edges of the design.

» After you've burned all of the outer edges, use the tip to fill in the lettering. These letters are thin enough to fill in quickly using the straight edge without needing to change tips.

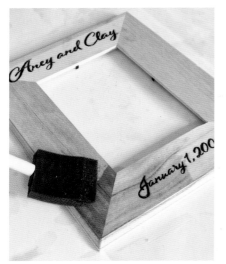

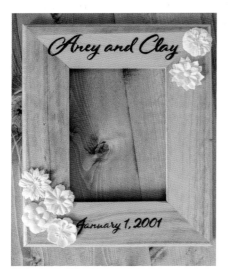

STEP THREE: VARNISHING AND ADDING THE DECORATIVE FLOWERS

» First, take out the piece of glass that came with your frame so you don't get varnish on it. Then grab your gloves, sponge brush and Danish oil. If you are varnishing the frame in an area that you want to protect from drips and spills, put down a couple layers of craft paper or cardboard for protection.

» Apply the Danish oil with the sponge brush, covering the entire frame, front and back. Allow the varnish to dry according to the manufacturer's directions.

» When the frame is dry, it's time to get creative with the paper flowers. We are going to add a few to the edge of the frame to give the finished piece a little flare.

» I chose white paper flowers that fit with the wedding theme of the frame, but you can choose a different color flower or even a different type of decoration altogether.

» Try positioning the flowers around the frame to get an idea of exactly where you want to glue them. Once you have the placement figured out, glue the accents in place.

FAMILY PHOTO *Hanger*

This family photo hanger is a simple project that will make you want to start printing your photos to display again. My favorite thing about this piece is how easy it is to update the pictures. Unlike a complicated frame, the small clips that hold the pictures can accommodate any size photo and make it easy to rotate your memories in and out.

For this project, you'll spend time practicing burning letters, and you'll continue to use a straight edge tip to outline the artwork. The more you practice burning with a straight edge, the better you will become at burning crisp lines for letters.

ABOUT THE WOOD

The shape of this canvas is an important part of the overall finished product. The four staggered panels give you four separate surfaces on which to work, making it the ultimate family photo hanger. Two panels will become the quote surface and the other two will become the photo space.

WHAT YOU'LL NEED

- Woodburning tool with a straight edge tip and a round tip 2
- Safety equipment: mask, fan and finger guards
- Templates (see pages 142–143)
- 32" x 10" (81.5 x 25.5–cm) four-panel wooden canvas with hanger (I got mine at Hobby Lobby)
- Carbon paper
- Pencil
- Tape
- Gloves
- Sponge brush
- Danish oil
- Craft paper or cardboard to protect your workspace (optional)
- 2 copper bulldog pushpin clips
- Wood glue
- Phillips head screwdriver (optional)

Tip

You can add multiple bulldog pushpin clips on the blank panels to hold smaller pics.

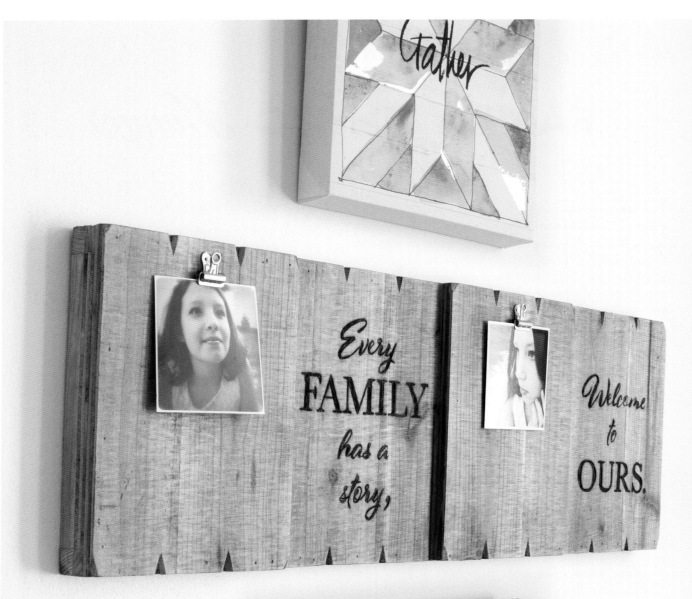

Gather

Every
FAMILY
has a
story,

Welcome
to
OURS.

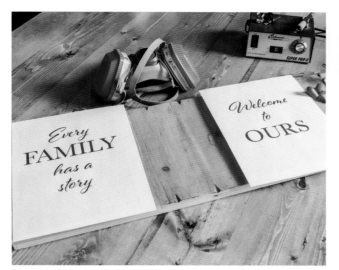

STEP ONE: SETTING UP AND TRANSFERRING THE ARTWORK

» The burning technique for this project will be very similar to the one used to make the Welcome Sign (page 19). You will outline letters and fill them in with a straight-line texture.

» Put a straight edge tip in your burner. Turn on your burner to medium-high and let it preheat while you set up your canvas in your workspace. You can still make this project even if your burner doesn't have heat settings. The default heat setting should be appropriate for burning faster and larger lines and shouldn't overpower the wood, but if your tip is too hot, you can always hold it in front of your fan for a few seconds to cool it off.

» As we discussed in Chapter One, safety equipment is important. Have your mask, fan and finger guards nearby and ready to go.

» Pull the templates on pages 142 to 143. Transfer the templates onto the wood using the carbon paper, pencil and tape. Refer to the Transferring Your Templates section in Chapter One (page 13) for details. Once you've finished, remove the templates and carbon paper, and make sure you didn't miss any lines.

Tip

I've found that pine wood has a lot of give and burns quickly. If you're using a pine canvas, you'll need to burn at a fast pace in order to prevent scorching the wood or creating deep, dark burn where you don't want it.

STEP TWO: OUTLINING AND FILLING IN THE LETTERS

» Now that your burner is nice and hot, you can burn all the outlines of the letters. Outlining the letters first makes it easier to fill them in later, and it gives the letters a nice crisp, clean edge.

» When you are burning the curves of the letters, go at a steady pace and try to keep your hand still as you guide the burner. It's easy to get comfortable with the straight lines, go too fast and then burn too far outside of the edges of the design.

» After you've completed all the outlining, turn off your burner and let it cool. Switch the tip to the round tip 2. Turn your burner back on and let it heat up to medium heat.

» Now that your letter outlines are all burned, fill them in with a straight-line pattern. Let's start with the letter E. You are going to burn straight horizontal lines inside each letter.

» Place the tip of the burner inside the left edge of the E and drag it across the wood's surface to the right side of the letter's edge. This creates a straight horizontal line. Place the tip of the burner just below the first horizontal line and drag it across to the right side again. The goal is for the burned lines to touch so that the whole surface is burned. Repeat this process until you have filled in the entire letter with straight horizontal lines.

» Continue burning inside all the letters until they are completely filled in.

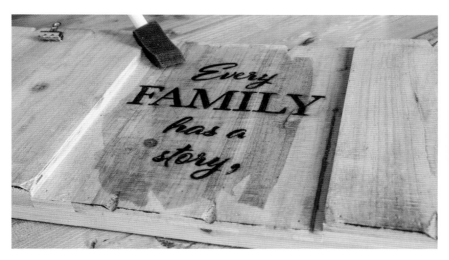

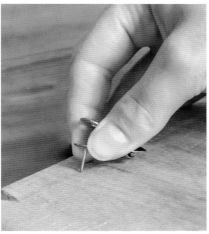

STEP THREE: VARNISHING AND ADDING THE COPPER CLIPS

» Grab your gloves, sponge brush and Danish oil. If you are varnishing the panels in an area that you want to protect from drips and spills, put down a couple layers of craft paper or cardboard for protection.

» Pour a small amount of the varnish over the wood and into the sponge brush. Spread the varnish all over the wood, covering every inch, front and back. This will help prevent moisture damage and warping. Allow the varnish to dry according to the manufacturer's directions. Once the first coat is dry, apply a second coat of Danish oil for added protection.

» Center a bulldog pushpin clip in the first blank panel of the canvas and slightly push the pin into the wood to make a small indention. Place a small amount of glue over the mark. The glue will help the clip attach to the wood and prevent it from wiggling. You want enough glue to hold the hanger in place, but not so much that a lot of excess is left.

» After you apply the glue to the canvas, place the pin of the clip back into the indention and push it all the way in. These pushpin clips are tough to push in, but you can't use a hammer because it will warp the clip. I've found using a Phillips head screwdriver helps push the nails all the way in.

» Repeat this process for the second blank panel.

» Now you're ready to hang your family photos in place.

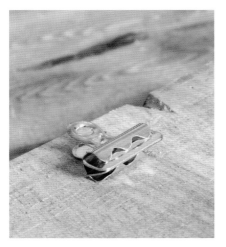

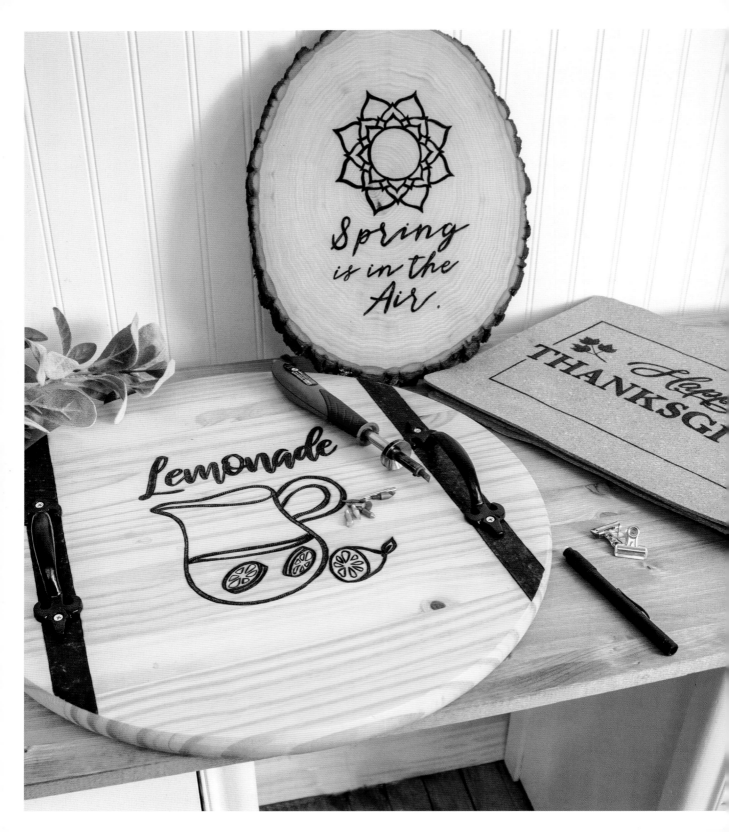

Three

SEASONAL PROJECTS

In this chapter, we will explore new burning techniques while creating projects for different times of the year. In Chapter Two we began with simple pyrography techniques in order to practice and gain familiarity with burning wood. The projects in Chapter Three are designed to take your burning to the next level. From new burning patterns to burning on cork, we will learn even more ways to experiment with a wood burner.

Woodburning abilities develop from practicing with different tips, types of wood and heat settings. By increasing the skill level one project at a time, your confidence will increase every time you try a new technique.

We will create a new door sign just for spring, a fun tray for serving drinks and snacks in the summer and cork placemats to delight your Thanksgiving guests.

Take a look at the projects in this chapter, gather your supplies and get ready to create.

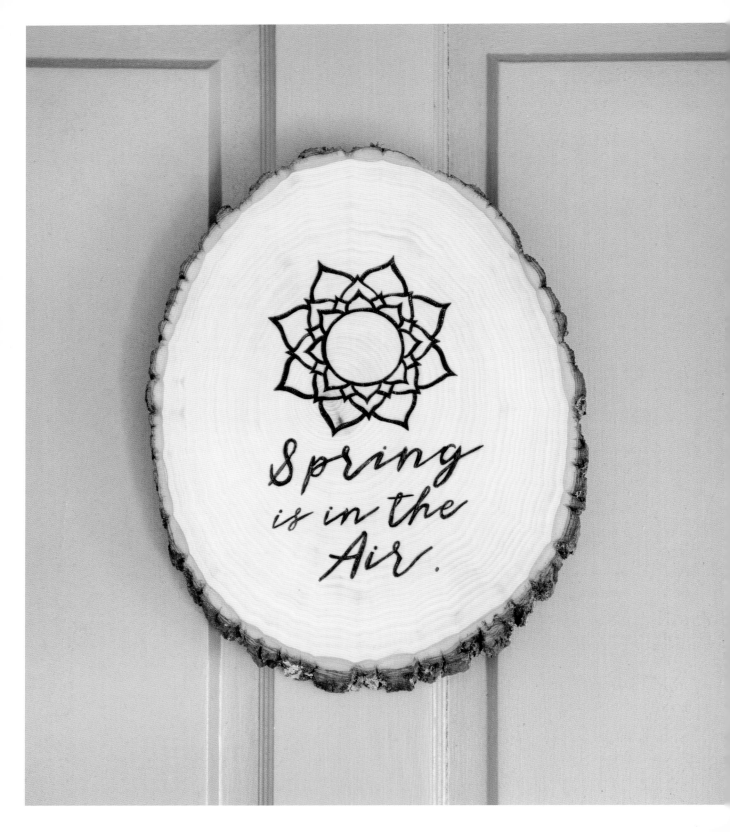

SPRING IS IN THE AIR
Door Sign

Spring is a great time of year to freshen up your décor with a few new pieces around the house. This easy door sign is a stylish way to greet your guests and usher in springtime cheer.

Basswood rounds with a live edge have a distinct look, and the wood is easy to burn. The modern flower template adds a contemporary feel, and the pretty script lettering softens the overall design.

ABOUT THE WOOD

Basswood and pyrography are a match made in crafting heaven. When you are working with a simple seasonal design, live-edge rounds are an outstanding choice for adding more visual interest to the finished piece. These rounds are essentially cross-sections of a tree's trunk, and the circular grain burns differently than the grain of traditionally milled canvases, resulting in a deeper, darker finish that makes for amazing lettering and silhouette designs.

WHAT YOU'LL NEED

- Woodburning tool with a straight edge tip and a round tip 1
- Safety equipment: mask, fan and finger guards
- Template (see page 144)
- 7–9" (18–23-cm) live-edge round canvas
- Carbon paper
- Pencil
- Tape
- Gloves
- Sponge brush
- Spar Urethane by Minwax
- Craft paper or cardboard to protect your workspace (optional)
- Sawtooth hanger with screws
- Phillips head screwdriver

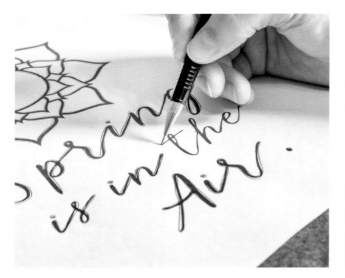

STEP ONE: SETTING UP AND TRANSFERRING THE ARTWORK

» Put a straight edge tip in your burner. Turn on your burner to medium-high and let it preheat while you set up your canvas in your workspace. You will be burning big lines in this project, so you can turn up the heat more if you want to burn at a faster pace.

» You can still make this project even if your burner doesn't have heat settings. The default heat setting should be appropriate for burning faster and larger lines and shouldn't overpower the wood, but if your tip is too hot, you can always hold it in front of your fan for a few seconds to cool it off.

» As we discussed in Chapter One, safety equipment is important. Have your mask, fan and finger guards nearby and ready to go.

» Pull the template on page 144. Transfer the template onto the wood using the carbon paper, pencil and tape. Refer to the Transferring Your Templates section in Chapter One (page 13) for details. Once you've finished, remove the template and carbon paper, and make sure you didn't miss any lines.

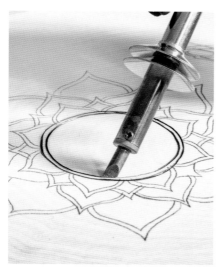 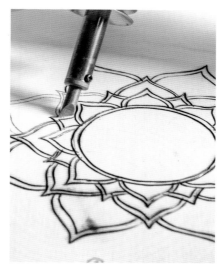

STEP TWO: OUTLINING THE LETTERS AND ARTWORK

» Now that your burner is nice and hot, begin by burning the straight lines in your flower and in each letter. T and I are a few examples of letters that have long straight lines. This is great way to work through the design quickly, and using the straight edge tip doesn't require a lot of technique.

» Now use the tip of your burner to finish burning the curves on your letters and flowers. When you are burning curved lines, go at a steady pace and try to keep your hand still as you guide the burner. It's easy to get comfortable with the straight lines, go too fast and then burn too far outside of the edges of the design.

» After you've completed all of the outlining, turn off your burner and let it cool. Switch the tip to the round tip 1. Turn your burner back on and let it heat up to medium heat.

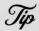

Tip

Add some color or accent pieces to your door sign that match your décor, if you'd like.

STEP THREE: FILLING IN THE LETTERS AND ARTWORK

» Now that your outlines are all burned, fill the letters and flower in with a straight-line pattern using the round tip. This is the same line texture pattern you used in the Welcome Sign project (page 19) and the Family Photo Hanger project (page 35).

» I love this pattern because it adds a nice texture to the letters instead of just a flat, solid burn. You are going to burn straight horizontal lines inside each letter. Place the tip of the burner inside the left edge of the letter and drag it across the wood's surface, to the right side of the letter's edge.

» This creates a straight horizontal line. Place the tip of the burner just below the first horizontal line and drag it to the right side again. The goal is for the lines to touch so the whole surface is burned.

» Repeat this process until you have filled in the entire letter with straight horizontal lines.

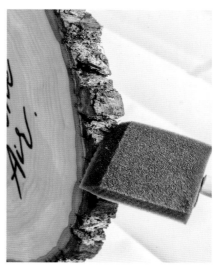

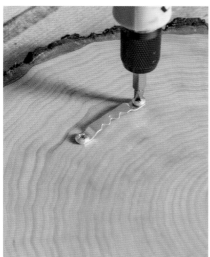

STEP FOUR: VARNISHING AND ADDING THE HANGER

» Grab your gloves, sponge brush and Spar Urethane. Read the directions about ventilation and recommended drying times before using it. Spar Urethane by Minwax is pretty strong stuff. If you are varnishing the sign in an area that you want to protect from drips and spills, put down a couple layers of craft paper or cardboard for protection.

» Pour a small amount of the varnish into the sponge brush and spread the varnish over the wood, covering the sign completely, front and back. This will help prevent moisture damage and warping. Allow the varnish to dry according to the manufacturer's directions.

» Grab your sawtooth hanger to attach to the back of the sign. Make sure the hanger you use has the capacity to hold the sign. The one I used was rated to hold 25 pounds (11 kg). Center the sawtooth hanger on the back of the sign and secure it in place with screws.

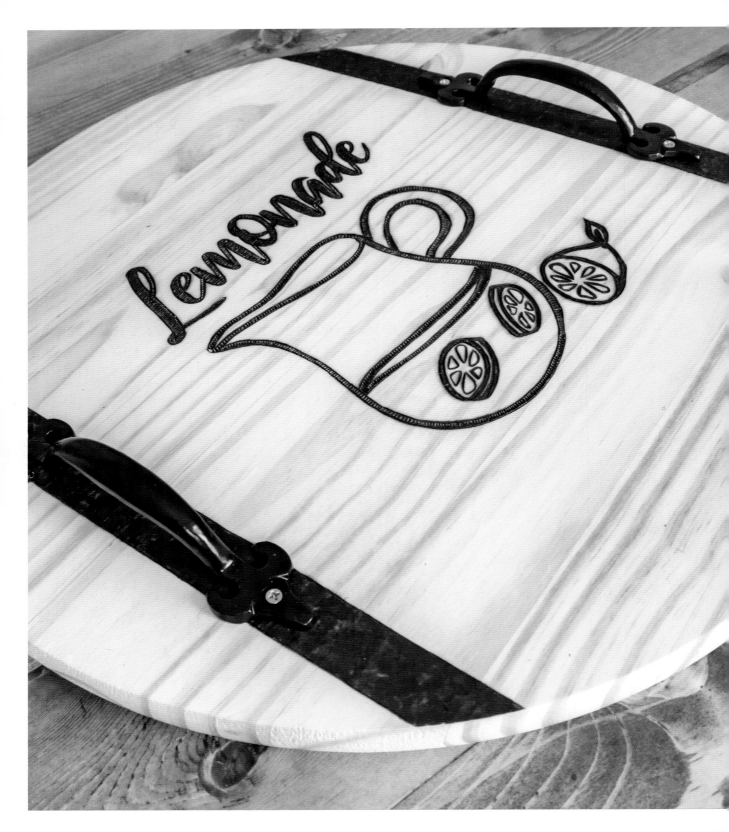

SUMMERTIME
Serving Tray

This serving tray is one of my favorite projects. My daughter created the design template, and every time I see it, I'm reminded of her generous contribution to this book. The design is fun to burn, and in the end, you'll have a practical piece to add to your kitchen collection. The materials you need to make the tray are inexpensive and readily available. It's also very easy to personalize the overall look of the tray by choosing handles that reflect your style.

The pine round for this project is sturdy and makes a perfect serving tray. Burning pine can be tricky because of the inconsistent grain pattern; however, the design is a straightforward silhouette with a deep burn throughout. This will give you another opportunity to practice burning straight lines with your straight edge tip on a challenging wood.

ABOUT THE WOOD

Size and weight are the most important factors when choosing a canvas for this project. It needs to be heavy and wide enough to hold the weight of drinks and snacks. This pine round was easy to burn, easy to find and inexpensive—the perfect crafting supply.

WHAT YOU'LL NEED

- Woodburning tool with a straight edge tip, a round tip 1 and a flat shading tip
- Safety equipment: mask, fan and finger guards
- Template (see page 145)
- 18" x 18" (46 x 46–cm) round, sanded pine wood (I got mine at The Home Depot)
- Carbon paper
- Pencil
- Tape
- Ruler
- Gloves
- Sponge brush
- Danish oil
- Craft paper or cardboard to protect your workspace (optional)
- Handles with predrilled holes and ¾" (2-cm) Phillips head screws
- Phillips head screwdriver
- 4 self-adhesive rubber feet (I got mine on Amazon)

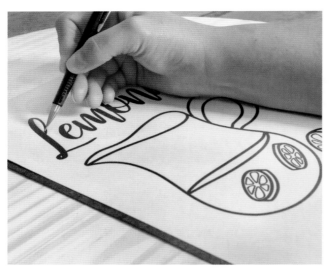 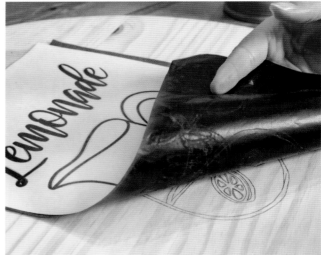

Tip

Instead of burning those wide lines on the side, paint them with a color that matches your kitchen décor. That will give your tray a pop of color and tie it into your decorating style.

STEP ONE: SETTING UP AND TRANSFERRING THE ARTWORK

» Put a straight edge tip in your burner. Turn on your burner to medium-high and let it preheat while you set up your canvas in your workspace. You'll be burning big lines and textures in this project, so you can turn up the heat more if you want to burn at a faster pace.

» You can still make this project even if your burner doesn't have heat settings. The default heat level should be appropriate for burning faster and larger lines and shouldn't overpower the wood, but if your tip is too hot, you can always hold it in front of your fan for a few seconds to cool it off.

» As we discussed in Chapter One, safety equipment is important. Have your mask, fan and finger guards nearby and ready to go.

» Pull the template on page 145. Transfer the template onto the wood using the carbon paper, pencil and tape. Refer to the Transferring Your Templates section in Chapter One (page 13) for details. Once you've finished, remove the template and carbon paper, and make sure you didn't miss any lines.

» You are also going to use the ruler in step three to add wide lines on each side of the tray.

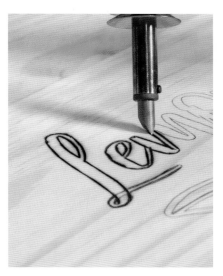
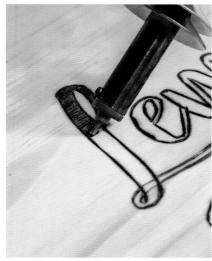
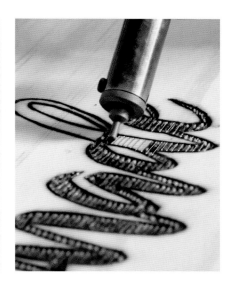

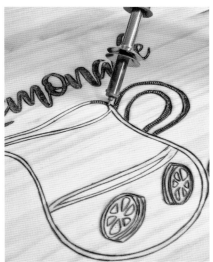

STEP TWO: BURNING THE LETTERS AND ARTWORK

» Now that your burner is nice and hot, you can burn the outline of the lemonade pitcher, lemons and letters. Follow the carbon lines on the wood until the outline of every item is burned.

» After you've completed all of the outlining, turn your burner off and let it cool. Switch the tip to the round tip 1. Turn your burner back on and let it heat up to medium heat.

» Now fill in the letters and artwork with a straight-line pattern. This is the same line texture pattern you used in the Welcome Sign project (page 19) and the Family Photo Hanger project (page 35).

» Let's start with the letter L. You are going to burn straight horizontal lines inside each letter. Place the tip of the burner inside the left edge of the letter L and drag it across the wood's surface to the right side of the letter's edge. This creates a straight horizontal line. The goal is for the burned lines to touch so that the whole surface is burned. Repeat the process until you have filled in the entire letter with straight horizontal lines.

» Continue burning inside all the letters until they are completely filled in. Then fill in the pitcher and lemons using the same technique.

» After you've filled everything in, turn your burner off and let it cool. Switch the tip to the straight edge tip. Turn your burner back on and let it heat up to medium heat.

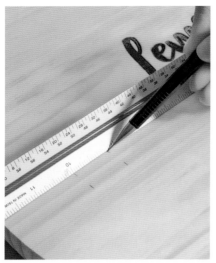

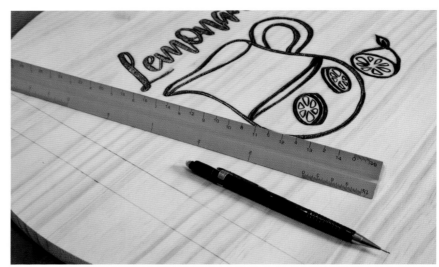

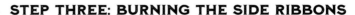

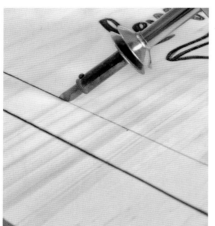

STEP THREE: BURNING THE SIDE RIBBONS

» While your burner heats up, use the ruler to draw lines that are 1 inch (2.5 cm) apart, on each side of the tray. You'll ultimately fill in the space between these lines with a flat burn, creating a wide ribbon on each side of the tray.

» Draw the first line 2 inches (5 cm) from the side of the tray that's parallel to the side of the lemonade artwork. The second line should be 1 inch (2.5 cm) from the first line, creating a 1-inch (2.5-cm) ribbon.

» Repeat the same process on the other side of the tray.

» Once your lines for the ribbons have been measured and drawn, burn the outlines of both ribbons, using the straight edge.

» After you've completed all of the outlining, turn off your burner and let it cool. Switch the tip to the flat shading tip. Turn your burner back on and let it heat up to high heat.

» Once the burner has heated up, fill in the ribbons on both sides with a dark flat burn.

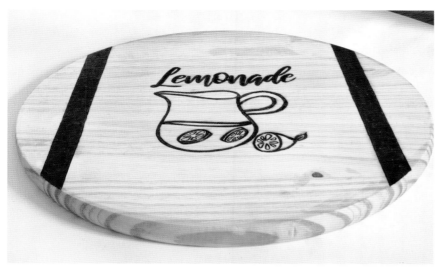

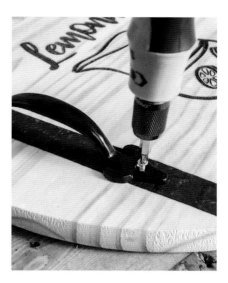

STEP FOUR: VARNISHING, ADDING THE HANDLES AND ADDING THE SELF-ADHESIVE RUBBER FEET

» Grab your gloves, sponge brush and Danish oil. If you are varnishing the serving tray in an area that you want to protect from drips and spills, put down a couple layers of craft paper or cardboard for protection.

» Pour a small amount of the varnish over the wood and into the sponge brush. Spread the varnish all over the wood, covering every inch, front and back. This will seal and protect the wood from moisture. Allow the varnish to dry according to the manufacturer's directions.

» Now, let's add on the handles. Start by positioning the handles on the board in the center of the ribbons you burned. You want to make sure the handles are centered so they will be balanced when you pick it up. You don't want to drop the tray when it's full of goodies!

» I chose handles that had predrilled holes so I could easily add the screws right through the top. The canvas is 1 inch (2.5 cm) thick, so I used ¾-inch (2-cm) screws.

» Once you have your handles where you want them, screw them into place.

» Now we'll add the rubber feet to protect surfaces and keep the tray from sliding. Flip over the canvas and mark where you will position the rubber feet. They should be equidistant from the center, evenly spaced and not too close to the edge of the canvas.

» After you've added the feet, your serving tray is ready to enjoy!

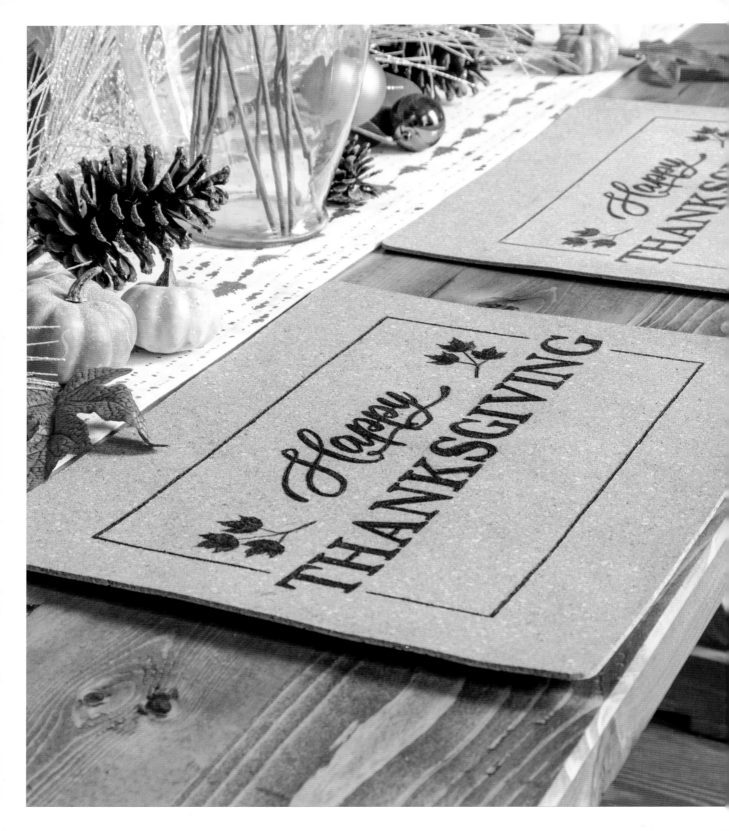

THANKSGIVING CORK
Placemats

One of the best ways to avoid conversation lulls at the Thanksgiving dinner table is to create an interesting dining experience. And if you're like me, going full Martha Stewart is challenging and too time consuming. My décor style tends to be a less-is-more theme, and these cork placemats fit the bill while still giving your guests an interesting visual to admire at dinner. They are excellent conversation starters. You'll have the opportunity to show off your woodburning skills and tell everyone about your wonderful new pyrography hobby, thus prompting everyone to talk about their hobbies, hopes and successes from the year.

The biggest challenges that creating these masterpieces entails is putting the design template together and adding the hand-drawn border without a template. I will walk you through the process step-by-step, so don't be intimidated. It only takes a small amount of effort to add the border and it's worth it.

WHAT YOU'LL NEED

- Woodburning tool with a straight edge tip and a flat shading tip
- Safety equipment: mask, fan and finger guards
- Template (see page 153)
- Scissors
- 4 (12" x 16" [30.5 x 40.5–cm]) cork mats (or more)
- Tape
- Carbon paper
- Pencil
- Ruler

ABOUT THE WOOD

Cork is an outstanding pyrography medium. It's not too expensive, burns easily and can be made into a large variety of projects. My favorite part about burning these placemats is how easily it burns. You can finish cork-based projects quickly on low heat settings.

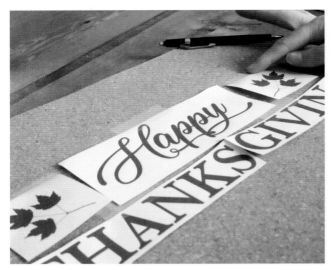

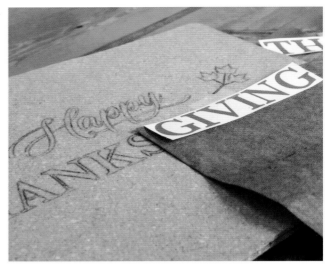

STEP ONE: SETTING UP AND TRANSFERRING THE ARTWORK

» Put a straight edge tip in your burner. Turn on your burner to low and let it preheat while you set up your canvas in your workspace. Cork burns much easier than wood and doesn't require very much heat.

» If your burner doesn't have heat settings, the default heat setting is likely too hot to achieve the best results. However, you can use your fan to temporarily cool the tip of the burner so it doesn't scorch the cork. You may have to place the tip in front of your fan several times throughout the burning process to maintain a low level of heat.

» As we discussed in Chapter One, safety equipment is important. Have your mask, fan and finger guards nearby and ready to go.

» Pull the template on page 153. The transfer method is going to be completed in pieces for this project. First, cut out the THANKS and GIVING pieces. Make sure they are centered horizontally and positioned slightly lower than the center of the mat before taping them down. When the word HAPPY is placed above THANKSGIVING, the full design should be centered vertically.

» After you have THANKSGIVING centered and taped, center HAPPY horizontally above THANKSGIVING and tape it in place. Once you have HAPPY positioned, take each cluster of leaves and place them on either side of the word and tape them down.

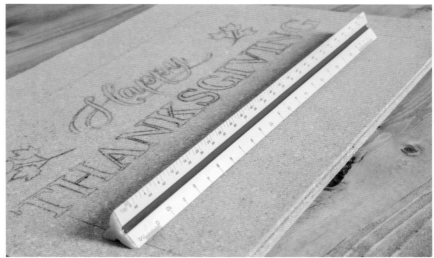

» Now you have your artwork ready and it's time to start transferring the design. Place your carbon paper under your templates and begin to trace your artwork onto the cork. Remember to press hard. Because the cork isn't solid like wood, there's a lot of give. Check your transfer often to make sure you can see the carbon lines on the cork. Keep the templates when you're finished, because you'll need to use them again for the rest of the mats.

» Now you are going to improvise a little bit and draw a rectangle around your artwork to frame the mat and bring all the elements together.

» Grab your ruler and place it about 3 inches (7.5 cm) from the top of the mat and draw a line. There's no set rule about how far from the edge it needs to be—just try to make sure there's an equal amount of space at the bottom of the mat to draw a parallel line.

» Once the top and bottom lines are drawn, place your ruler about an inch (2.5 cm) from the left side of the mat. Draw a line, but don't overlap the T in THANKSGIVING. Do the same on the right side of the mat, but don't overlap the G in THANKSGIVING.

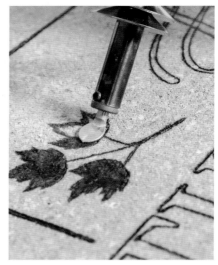

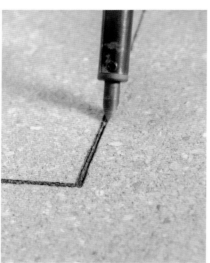

STEP TWO: BURNING THE LETTERS, ARTWORK AND BORDERS

» Now that your burner is nice and hot, you can burn all the outlines of the letters. First, burn all of the small lines by turning the burner tip at an angle so that a small part of the burner is touching the cork.

» Burn the straight lines in the letters next. I like to burn all of the vertical lines and then go back and burn all of the horizontal lines. Then use the tip of your burner to finish burning the curves of your letters and leaves.

» After you've completed all of the outlining, turn your burner off and let it cool. Switch the tip to the flat shading tip. Turn your burner back on and let it heat up to low heat.

» Fill in the letters and leaves with a flat burn. You can turn the flat shading tip on its side when you need to fill in thinner areas. Keep going until all your letters are completely filled in.

» After the inside design is complete, turn your burner off and let it cool. Switch the tip back to the straight edge tip. Turn your burner back on and let it heat up.

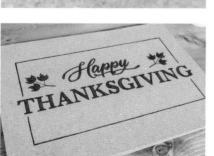

» When your burner is hot again, burn the rectangle border. Burn two rows for each line so the borders stand out nice and bold on the mat.

» Once you have burned all of your lines, you are finished! Repeat the steps for the other three cork mats, or as many as you like.

MANDALA *Ornaments*

Mandala art is captivating to look at. The symmetry and patterns draw us in and make us want to examine the details further. They symbolize life energy, and in Sanskrit, the word mandala means "circle." We are going to capture the essence of a mandala with pyrography. The relaxing repetition of burning the shapes into the wood will keep you motivated and focused throughout this project. And the mandala ornament will mesmerize you and your family for years to come as it is displayed proudly on your Christmas tree, or hanging wherever you'd like!

The dot pattern you'll use in this project is used often in pyrography, so I wanted to include a project that demonstrates the technique. The round tip 1 in particular makes burning the dots effortless. The most challenging part of burning the dots is the time and patience it requires.

ABOUT THE WOOD

I used pine wood rounds for this project, which are dense and have an inconsistent grain pattern. When burning, you'll have to pay attention to the alternating hard and soft grains in order to burn crisp lines. Working slowly and keeping a steady hand also helps. A straight edge tip is especially good for burning clean lines.

WHAT YOU'LL NEED

- Woodburning tool with a straight edge tip and a round tip 1
- Safety equipment: mask, fan and finger guards
- Template (see page 145)
- Scissors
- 3–4" (8–10-cm) live-edge wooden rounds, with predrilled holes
- Tape
- Carbon paper
- Pencil
- Gloves
- Sponge brush
- Danish oil
- Craft paper or cardboard to protect your workspace (optional)
- Decorative string

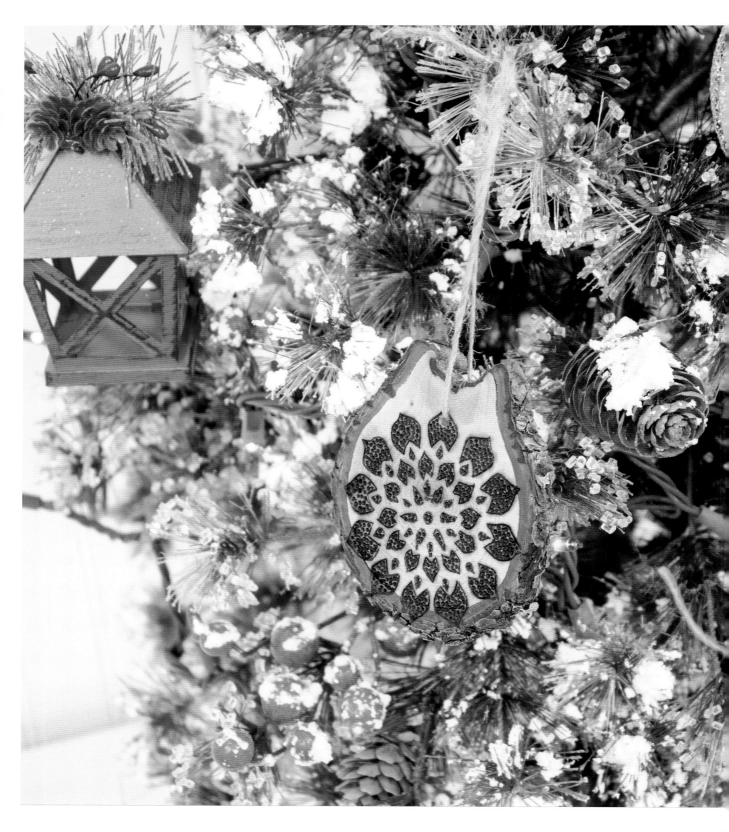

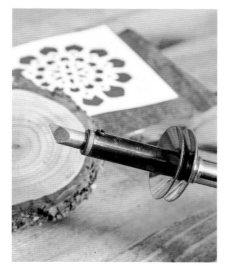

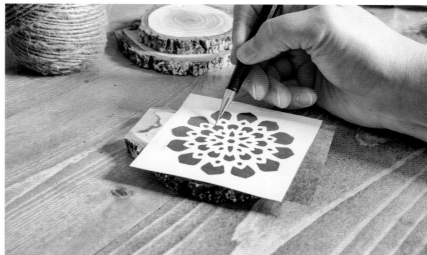

STEP ONE: SETTING UP AND TRANSFERRING THE ARTWORK

» Put a straight edge tip in your burner. Turn on your burner to medium-high and let it preheat while you set up your canvas in your workspace. You will be burning lines only in this project, so you can turn up the heat more if you want to burn at a faster pace.

» You can still make this project even if your burner doesn't have heat settings. The default heat setting should be appropriate for burning faster and larger lines and shouldn't overpower the wood, but if your tip is too hot, you can always hold it in front of your fan for a few seconds to cool it off.

» As we discussed in Chapter One, safety equipment is important. Have your mask, fan and finger guards nearby and ready to go.

» Pull the template on page 145 and trim it to size. Center it on the wooden round and secure it in place with tape. Transfer the template onto the wood using the carbon paper and pencil. Refer to the Transferring Your Templates section in Chapter One (page 13) for details. Once you've finished, remove the template and carbon paper, and make sure you didn't miss any lines. Repeat this process for all the ornaments.

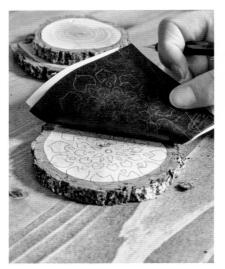

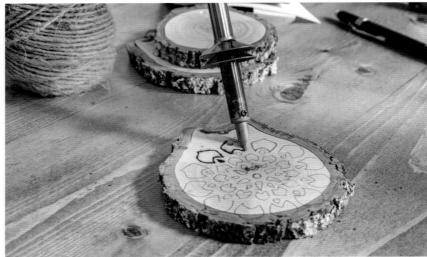

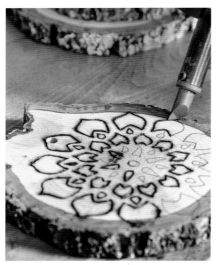

STEP TWO: BURNING THE OUTLINE

» Now that your burner is nice and hot, you can start burning the outline of the ornament design. Pine wood rounds can be tricky to burn because they are dense and have an inconsistent grain pattern. You'll have to pay attention to the alternating grains in order to create crisp lines. Take your time and follow the carbon lines slowly. If you burn too fast, you may get some bumpy lines.

» After you've completed burning the design, turn off your burner and let it cool. Switch the tip to the round tip 1. Turn your burner back on and let it heat up to medium heat.

Tip

If you're getting bumpy lines, take the time to go back and make adjustments. It won't hurt to retrace your steps and clean up any edges that aren't sharp. Using the pointed tip is ideal for this kind of detailed cleanup work if you need it.

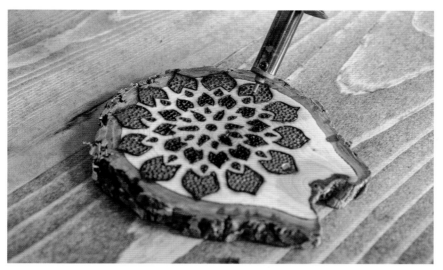

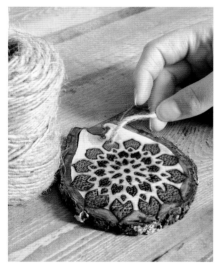

STEP THREE: FILLING IN THE ARTWORK, VARNISHING AND ADDING THE DECORATIVE STRING

» Once your burner is hot again, it's time to add texture and fill in the design.

» We are going to texture this project with a multishade dot pattern. Start by lowering the temperature of your burner to achieve a lighter shade on the outer petal of the design. Simply touch the wood with the tip of your burner, creating small dots that are close together and continue around the outer petal.

» Now, we'll fill in the inner section with a darker shade. Turn up the heat slightly and leave your tip on the wood a bit longer to create a darker color that you like. Continue filling in the entire inner section with the dot pattern until the whole design is burned.

» Grab your gloves, sponge brush and Danish oil. If you are varnishing the coasters in an area that you want to protect from drips and spills, put down a couple layers of craft paper or cardboard for protection.

» Load your sponge brush with varnish and cover the ornaments completely, front and back. This will seal and protect the wood from moisture. Allow the varnish to dry according to the manufacturer's directions.

» Add some decorative string to jazz these up. Feel free to try different colored ribbons and experiment with different looks. Just pull the string/ribbon through the hole in the round and tie in a knot.

» Now you have a great piece to give as a gift, hang in your house or use as a paperweight—really whatever you feel like doing with it.

Tip

If you're confident with paint, try adding color around the edges of the design before you add the varnish.

Four

PRACTICAL PYROGRAPHY

Burning art pieces to hang on the wall is great, but when you combine craftiness with pyrography, you can create a whole new set of fun and functional projects. In this chapter, you will step outside the bounds of wall art and experiment with different ways to incorporate woodburning into projects you can use every day. From key chains to calendars, there's no limit to what you can do with pyrography.

These practical pieces will also include new pyrography techniques like freehanding, working with layered canvases and adding other materials to the canvas. These projects were specifically designed to expand the idea of what pyrography is and can be. Woodburning doesn't have to be limited to flat pieces of wall art. Adding woodburned designs to functional items can transform them into unique works of art.

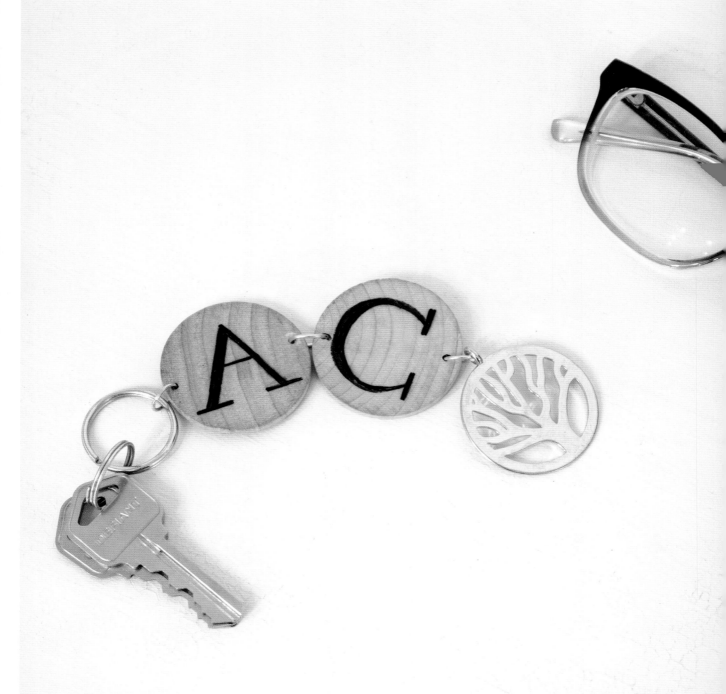

MONOGRAM *Key Chains*

You can opt to use the lettering templates in Chapter Seven (page 151) for this project or go out on a limb and sketch your own. You are truly in charge of taking this project in the creative direction you want. I'll be here guiding you along, but the crafting decisions are up to you. These little wooden circles are usually only sold in bulk bags, so you'll be able to try and try again until you achieve the lettering look you desire. If you have leftover wooden rounds after completing this project, you can use them to make the Essential Oil Necklaces on page 77.

ABOUT THE WOOD

These little pine circles are excellent pyrography canvases. The size is large enough to burn in large monogram initials, but they aren't too bulky for a key chain. The pine is soft, which will result in dark, deep silhouettes and letters. It's easy to scorch these tiny pine canvases, so be careful not to let your burner get too hot. Work slowly and, most importantly, have fun.

WHAT YOU'LL NEED

- Woodburning tool with a straight edge tip
- Safety equipment: mask, fan and finger guards
- 2 (1½" [4-cm]) round wood circles (I got mine at Hobby Lobby)
- Scrap wood
- Hammer
- Nail
- Pencil
- Templates (see page 151)
- Scissors
- Carbon paper
- Tape
- Essential oils
- Jewelry pliers or needle nose pliers
- 3 (9-mm) jump rings
- A small charm of your choice with a ring
- Key chain ring

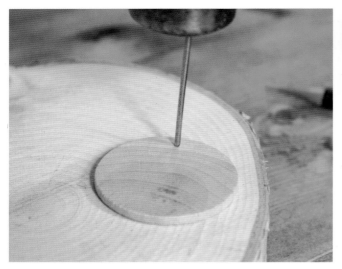
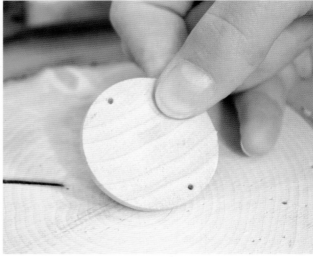

Tip

You can also find these little pine circles online with predrilled holes.

STEP ONE: SETTING UP AND NAILING THE HOLES

» Put a straight edge tip in your burner. Turn on your burner to medium and let it preheat while you set up your canvas in your workspace. You will be burning small lines in this project, and working with less heat will allow you to work at a slower pace and control the burner more easily.

» If your burner doesn't have heat settings, the default heat setting is likely too hot to achieve the best results. However, you can use your fan to temporarily cool the tip of the burner so it doesn't scorch your wood. You may have to place the tip in front of your fan several times throughout the burning process, especially when you're burning some of the smaller lines.

» As we discussed in Chapter One, safety equipment is important. Have your mask, fan and finger guards nearby and ready to go.

» This is a very delicate part of the process. These wooden circles are small and thin, so adding the holes for the jump rings can cause the wood to crack. If you hammer too fast and too hard, it will probably break. If you wait to do this step at the very end, you may damage the artwork you created and have to start all over again.

» You'll be adding two holes on opposite sides of each wood circle in order to connect them together. Place the circle on top of your scrap wood piece. Grab your hammer and your nail. Make sure the nail is large enough to let the jump ring pass through. Hammer the nail into the circle very slowly and gently, about ⅛ inch (0.3 cm) from the edge. Repeat the process on the opposite side of the wood circle.

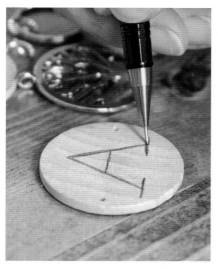

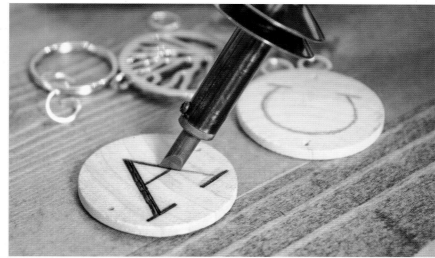

STEP TWO: TRANSFERRING THE ARTWORK AND BURNING THE LETTERS

» If you decide to freehand your monogram letters, all you need is a pencil to sketch your designs onto the wood rounds.

» If you decide to use the lettering templates to monogram these circles, refer to page 151 to find the font you like and cut out your initials. Transfer the template onto the wood using the carbon paper, pencil and tape. Refer to the Transferring Your Templates section in Chapter One (page 13) for details. Ideally the monogram letters should be centered vertically on the wood circles, with the nail holes directly to the left and right of each letter. Because of their size, transferring the template onto these circles can be a bit tricky. Using smaller pieces of tape to secure the template will help. Once you've finished, remove the template and carbon paper, and make sure you didn't miss any lines.

» Once you've finished getting your artwork set up, it's time to start burning the monogram letters. Follow the carbon lines on the wood with the tip of your burner, working slowly and carefully, and try to burn clean, crisp lines. You can go back over the areas with any bumps or jagged edges.

» Burn all of the letters on your wood pieces.

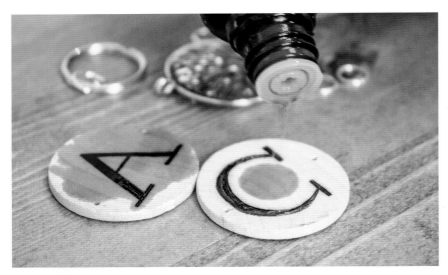

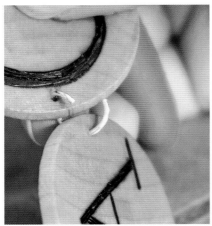

STEP THREE: ADDING THE OILS AND ASSEMBLING THE KEY CHAIN

» Now for the oils—the most satisfying part! Add several drops to each wood circle. Make sure there's enough oil to fully saturate the wood. Let it soak in for about 3 minutes.

» Now you're ready to assemble the key chain. First, use your pliers to open a jump ring and slide it into the hole at the top of the wood circle with your first initial on it. It's easier if you hold the jump ring with your pliers and hold the wooden circle with your hand. Close the jump ring with the pliers once it's in place.

» Add a jump ring to the hole at the bottom of the same wooden circle, and, while it's still open, add the second initial circle to the same jump ring. Once both wooden circles are in place, close the jump ring with your pliers.

» Add the last jump ring to the hole at the bottom of the second wooden circle. While it's still open, add the charm you selected, and then close the jump ring. Attach the key chain to your key chain ring.

» Now you have a monogrammed key chain with a refreshing essential oil scent.

Tip

Different wood shapes and font styles are fun to experiment with in this project. For instance, you could burn your initials or a meaningful symbol into a small teardrop-shaped wood piece.

TEXTURED-PATTERN *Clock*

Freehand time! For this clock project, I want you to go nuts and burn just for the sake of burning. No patterns, no agendas and no end goal—just burning. The beauty of burning without a design is having the chance to develop a style that is all your own. Put your burner to the wood and see what happens.

In the instructions, I'll guide you somewhat in how to lay out the numbers of the clock's face, because those do actually need to go in specific locations. However, what you burn around those numbers is completely up to you.

Freehand burning is my favorite way to burn. When I burn without a template, I feel the most freedom and sense of accomplishment. I'm usually pleasantly surprised by the end result, considering I had no plan in the beginning. My hope for you as you experiment with freehand burning is that you'll learn more about what you love about pyrography and why you love it. It's not always about creating a perfect piece. Sometimes you need to just sit down with your burner and explore what it feels like to not know what's going to happen.

WHAT YOU'LL NEED

- Woodburning tool with a straight edge tip and a round tip 1
- Safety equipment: mask, fan and finger guards
- ArtMinds 10" x 10" (25.5 x 25.5–cm) round basswood canvas with predrilled hole made for ¾" (2-cm) clock parts (I got mine at Michaels)
- Ruler
- Pencil
- Small 1½" (4-cm) circle
- Gloves
- Sponge brush
- Danish oil
- Craft paper or cardboard to protect your workspace (optional)
- Clock parts
- Light blue and gold paints (or colors of your choice)
- Paintbrush
- AA battery

ABOUT THE WOOD

A premade clock face was an easy choice for this canvas. The round basswood one I selected has a predrilled hole for installing the clock parts, and the soft wood makes it easy to burn in deep texture details.

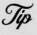 Tip

Double check that the stem of the main clock mechanism is the right length for your canvas. The canvas is made for ¾-inch (2-cm) clock parts, so make sure the stem is compatible.

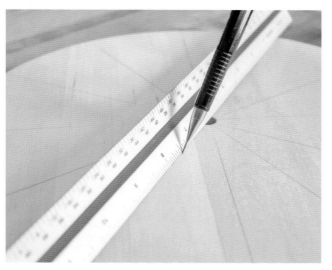

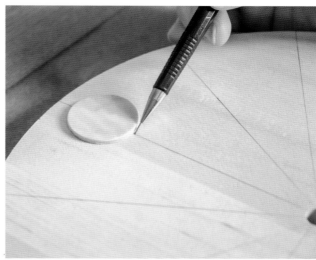

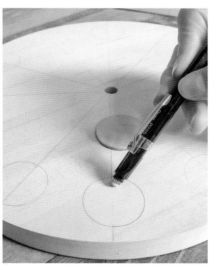

Tip

If you spot some lines that aren't evenly spaced, simply erase and redraw until it comes out right.

STEP ONE: SETTING UP AND DRAWING THE CIRCLES FOR THE NUMBERS

» Put a straight edge tip in your burner. Turn on your burner to medium-high and let it preheat while you set up your canvas in your workspace. You will be burning big lines in this project, so you can turn up the heat more if you want to burn at a faster pace.

» You can still make this project even if your burner doesn't have heat settings. The default heat setting should be appropriate for burning faster and larger lines and shouldn't overpower the wood, but if your tip is too hot, you can always hold it in front of your fan for a few seconds to cool it off.

» As we discussed in Chapter One, safety equipment is important. Have your mask, fan and finger guards nearby and ready to go.

» You are going to wing it on this one. No templates, just freehand!

» First, use a ruler to draw a straight line down the middle of the canvas and a second line perpendicular to the first line. These lines will help you figure out where to place the 12, 6, 3 and 9. Then you can draw the rest of the lines for the remaining numbers.

» Now that your lines are drawn, you can start adding all of the numbers. First, take the small circle and place it at the end of each line, about ¼ inch (0.5 cm) from the edge of the wood. Trace the outline.

» Repeat the same step for each line all the way around the clock. You will be drawing a circle for each number of the clock. Erase the pencil lines inside the circles.

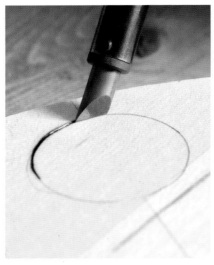

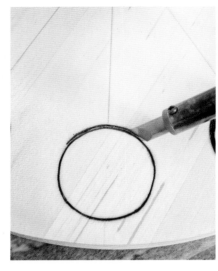

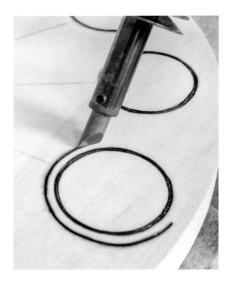

STEP TWO: BURNING THE CIRCLES AND FREE PLAY

» Now it's time to burn the traced circles. You'll want to create a ring for each number on the clock's face to go inside. Place your burner tip on one of the circles you drew and follow the outline with your straight edge tip all the way around. Then trace a second circle around the first one to give it some weight and substance. Repeat this process with the other eleven circles.

» After you've burned all the circles, you're going to add a third circle, to create an unburned area of space around all the numbers that will act as a barrier to the freehand burning you'll add in the next step.

» Here's the crazy fun part. Since you don't have a template, you can create any pattern or texture you want. I decided to burn in a series of waves, lines and circles. Your design can be completely random or you can add in a series of patterns. Go crazy with it. Fill in the entire background up to the outer circles you burned in the previous step.

» When you've finished filling in the entire canvas with burned patterns, turn off your burner and let it cool. Switch the tip to the round tip 1. Turn your burner back on and let it heat up to medium heat.

» In the meantime, grab your pencil to sketch the numbers of the clock.

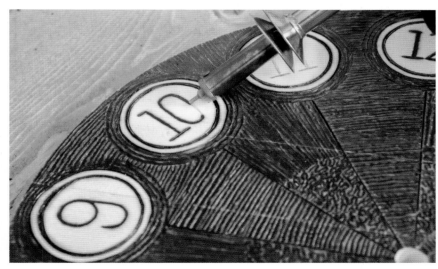

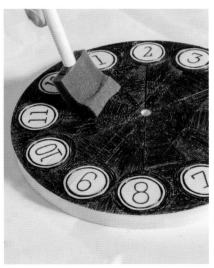

STEP THREE: ADDING THE NUMBERS AND VARNISHING

» With your pencil in hand, start sketching each number in the circles. Start with 12, then work your way around the clock. I went with a very simple number style.

» After you've sketched all the numbers, start burning over your sketched artwork.

» Burning straight lines without bumps is a little tricky, but the beauty of this project is that it is free play. It doesn't need to be completed with perfectly straight lines. You can use your round tip 1 to create a freehand look that is intentionally imperfect.

» Add the varnish to your canvas before installing the clock parts. Grab your gloves, sponge brush and Danish oil. If you are varnishing the clock in an area that you want to protect from drips and spills, put down a couple layers of craft paper or cardboard for protection.

» Pour a small amount of the varnish over the wood and into the sponge brush. Spread the varnish all over the wood, covering every inch, front and back. Allow the varnish to dry according to the manufacturer's directions.

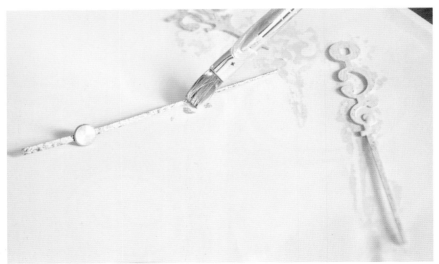

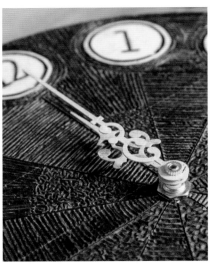

STEP FOUR: PAINTING AND ADDING THE HANGER

» Before assembling the clock parts, I decided to paint them. The back of the clock was so dark and the clock hands that I purchased were black, which made them harder to see on the burned wood. Instead of buying a different set of clock parts, I painted the hour and minute hands blue and my second hand gold, just for a bit of contrast.

» Grab your gloves, paintbrush and paint. If you will be painting your clock hands in an area that you want to protect from drips and spills, put down a couple of layers of craft paper or cardboard for protection. Once all three of the clock hands are dry, check to see if they need a second coat. If not, you can move on to assembling the clock parts.

» The clock part kit comes with instructions for adding it to a clockface. Follow the kit directions to put it together. Add the battery and you're all set.

ESSENTIAL OIL *Necklaces*

Essential oils are one of my favorite things in life, so I knew I wanted to incorporate them into a few projects. Creating an essential oil necklace is the perfect way to carry the scent of your favorite oils with you on the go. These little wooden circles are cut against the grain, meaning they aren't cut like wooden planks that have straight grain patterns. Rather, they are cut so that the wood rings are visible, which makes them extra porous and able to absorb essential oils.

I'm going to show you four different necklace patterns in this project. You can burn all four or you can skip to your favorite and burn that one. The details are small and simple, so keep your heat settings low and have fun with it.

ABOUT THE WOOD

These little precut pine circles are great for making pyrography accessories, including Monogram Key Chains (page 67). The wood soaks up essential oils and diffuses the scent for a few hours.

WHAT YOU'LL NEED

- Woodburning tool with a straight edge tip and a pointed tip
- Safety equipment: mask, fan and finger guards
- 4 (1½" [4-cm]) round wood circles (I got mine at Hobby Lobby)
- Scrap wood
- Hammer
- Nail
- Templates (see page 149)
- Scissors
- 3 (½" [1.3-cm]) wood circles (I got mine in a mixed bag of small wooden shapes from Hobby Lobby)
- Carbon paper
- Pencil
- Tape
- Wood glue
- Jewelry pliers or needle nose pliers
- 4 (9-mm) jump rings
- 4 premade necklace chains with clasps
- Essential oils

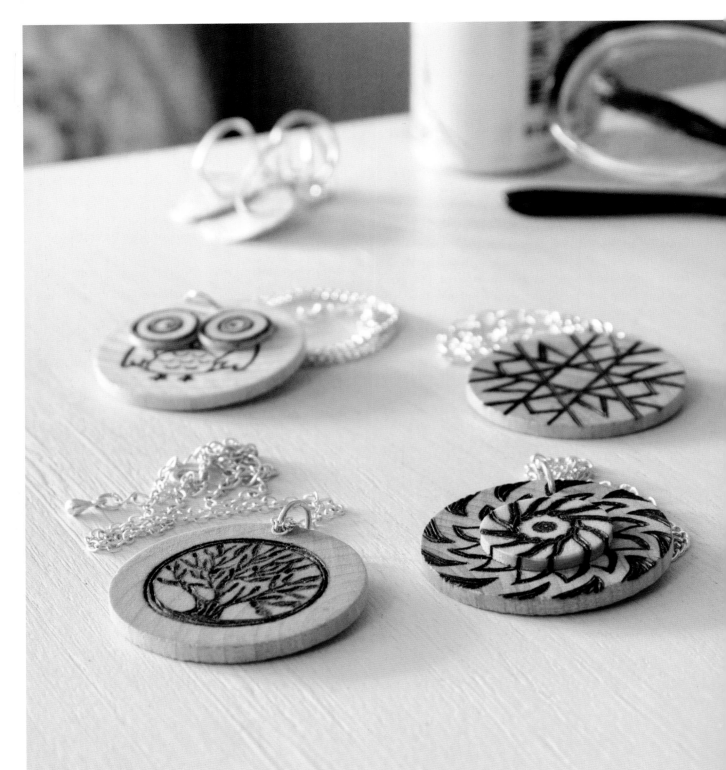

You can find these little pine circles online with predrilled holes.

STEP ONE: SETTING UP AND NAILING THE HOLES

» Put a straight edge tip in your burner. Turn on your burner to medium and let it preheat while you set up your canvas in your workspace. You will be burning small lines in this project, and working with less heat will allow you to work at a slower pace and control the burner more easily.

» If your burner doesn't have heat settings, the default heat setting is likely too hot to achieve the best results. However, you can use your fan to temporarily cool the tip of the burner so it doesn't scorch your wood. You may have to place the tip in front of your fan several times throughout the burning process, especially when you're burning some of the smaller lines.

» As we discussed in Chapter One, safety equipment is important. Have your mask, fan and finger guards nearby and ready to go.

» This is a very delicate part of the process. These wooden circles are small and thin, so adding the hole for the jump rings can cause the wood to crack. If you hammer too fast and too hard, it will probably break. If you wait to do this step at the very end, you may damage the artwork you created and have to start all over again.

» Place the 1½-inch (4-cm) circle on top of your scrap wood piece. Grab your hammer and your nail. Make sure the nail is large enough to let the jump ring pass through. Hammer the nail into the circle very slowly and gently, about ⅛ inch (0.3 cm) from the edge. That will provide enough space to add the jump ring. Repeat for all the 1½-inch (4-cm) circles.

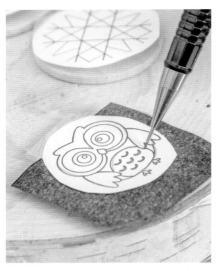

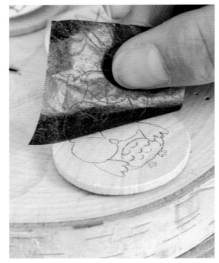

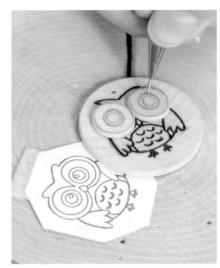

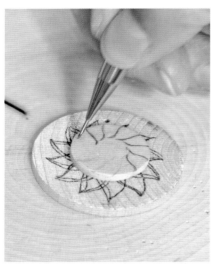

STEP TWO: TRANSFERRING THE ARTWORK

» I've provided four different templates, so by the end of this project you'll have four completed necklaces. You'll need to grab four of the 1½-inch (4-cm) circles and three of the ½-inch (1.3-cm) circles.

» Pull the templates on page 149 and cut them down to size. Transfer the template onto the wood using the carbon paper, pencil and tape. Refer to the Transferring Your Templates section in Chapter One (page 13) for details. Ideally the design templates should be centered vertically on the wood circles, with the nail hole directly above the top of the artwork. Because of their size, transferring the template onto these circles can be a bit tricky. Using smaller pieces of tape to secure the template will help. Once you've finished, remove the template and carbon paper, and make sure you didn't miss any lines.

» Feel free to improvise here, too. You can get creative and make your own shapes, letters or art freehand. Grab a pencil and sketch it out on the wood circles before you burn.

» For the ½-inch (1.3-cm) wood circles, creating a freehand design with a pencil is ideal since they are too small to use with the carbon paper transfer method. Don't worry about getting it perfect, just have fun with it.

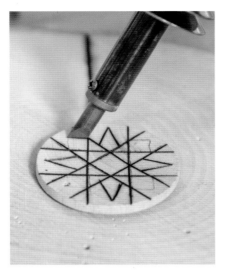 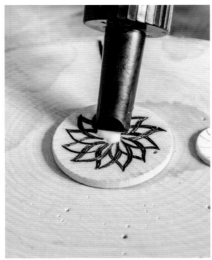 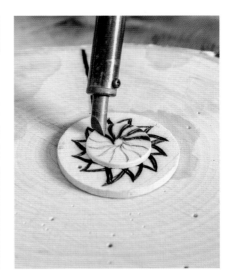

STEP THREE: BURNING THE NECKLACE PENDANTS

» You will be burning simple designs on each necklace pendant, which will help you get familiar with burning on small pieces. The designs are simple so you can just focus on using your straight tip to burn in small spaces. This will help you get better at using the straight edge tip as well. You'll add the pendants to a necklace chain in step four.

Geometric Necklace

» This design is a great one to start with because it's simple and consists of all straight lines. Simply follow the carbon lines on the wood with the tip of your burner. I like to go back and double each line so they appear straighter and more prominent at a distance.

Sun Necklace

» For this design, burn the carbon lines you transferred on the larger circle first. The straight edge tip makes it easier to get these lines straight without a lot of bumpy edges. Keep burning in each area until you've gone all the way around.

» Once you're finished burning the larger circle, glue the ½-inch (1.3-cm) circle on top of it. Once the glue is dry, you can burn the design on the ½-inch (1.3-cm) circle using your straight edge tip. Use the same burning technique with your tip as you did to burn the larger circle.

» I felt like this design was a little bare, so I added some detailing to the edges. Feel free to leave yours as is or add in anything you want.

If your woodburning tool doesn't have heat settings, remember to place the tip in front of the fan for a few seconds to temporarily cool it down as needed for the fine details.

Tree Necklace

» As with the other pendants, follow the carbon lines on the wood with the tip of your burner to burn the entire tree pattern. Turn the tip up slightly so that only a small portion of the tip is touching the wood.

» If you'll be making the owl necklace next, turn off your burner and let it cool. Switch the tip to the pointed tip. Turn your burner back on and let it heat up.

Owl Necklace

» This is a fun design and my personal favorite. All you have to do is use your pointed burner tip to follow the carbon lines you transferred onto the wood.

» Once your large circle is burned, grab two ½-inch (1.3-cm) circles and glue them in place of the eye spots. When the glue dries, you can finish burning in the design on the top circles. Because these circles are so small, the edges aren't going to be perfect, and that's okay. The owl will be so cute; no one will notice. Turning the tip of your burner up a little so that only a small portion of the tip is touching the wood will give you more control over burning the small lines.

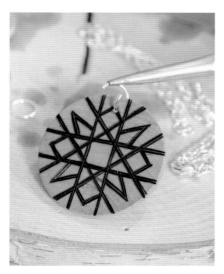
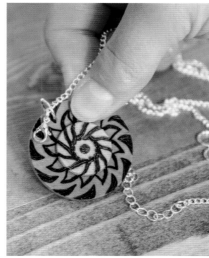

STEP FOUR: ASSEMBLING THE NECKLACES AND ADDING THE OILS

» Now we will add all of the jewelry findings to the pendants. Grab your pliers, jump rings and premade necklace chains.

» First, use your pliers to open a jump ring, and slide it into the hole on one of the pendants you just made. It's easier if you hold the jump ring with your pliers and hold the wooden circle with your hand.

» Next, lay a necklace chain on the jump ring, too. Don't attach the chain to the jump ring—you want the chain to slide through the jump ring when it's closed. Lastly, use your pliers to close the jump ring. Repeat this process with all four chains.

» Now for the oils—the most satisfying part! Add several drops to each wood circle. Make sure there's enough oil to fully saturate the wood but not so much that the oil will transfer onto any clothing. Let it soak in for about 3 minutes.

» Now you have four essential oil necklaces. The wood pendants soak up the oils and release the scent for several hours.

THOUGHT OF THE DAY

GOOD VIBES

THOUGHT OF THE DAY
Chalkboard

The woodburning for this project is minimal. The overall crafting of the piece is focused more on having a space to post thoughts, memes, quotes or anything that is the highlight of your day. I love the versatility of having a place to be funny or post deep thoughts. I personally use my thought of the day board for funny quotes and memes. I have it hanging at work and share my favorite funnies with my coworkers. It always gets a laugh or starts a conversation. I enjoy being able to use this small piece of basswood to bring joy to others.

ABOUT THE WOOD

Canvas size is important in this project. The canvas needs to be large enough to accommodate your thoughts, quotes and doodles. I chose a board with a big surface area and a live edge to add more interest to the piece.

WHAT YOU'LL NEED

- Woodburning tool with a round tip 2 and a straight edge tip
- Safety equipment: mask, fan and finger guards
- Template (see page 145)
- 11" x 13" (28 x 33-cm) basswood live-edge board (I got mine at Hobby Lobby)
- Carbon paper
- Pencil
- Tape
- 12" x 16" (30.5 x 40.5-cm) chalkboard sheet
- Chalk
- Ruler
- Scissors
- Gloves
- Sponge brush
- Danish oil
- Craft paper or cardboard to protect your workspace (optional)
- Wood glue
- Copper bulldog pushpin clip
- Phillips head screwdriver
- Sawtooth hanger with screws

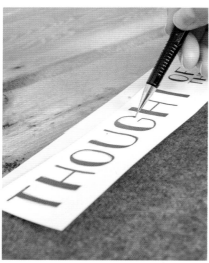

STEP ONE: SETTING UP AND TRANSFERRING THE ARTWORK

» Put a round tip 2 in your burner. Turn on your burner to medium and let it preheat while you set up your canvas in your workspace. You will be burning small lines in this project, and working with less heat will allow you to work at a slower pace and control the burner more easily.

» If your burner doesn't have heat settings, the default heat setting is likely too hot to achieve the best results. However, you can use your fan to temporarily cool the tip of the burner so it doesn't scorch your wood. You may have to place the tip in front of your fan several times throughout the burning process, especially when you're burning some of the smaller lines.

» As we discussed in Chapter One, safety equipment is important. Have your mask, fan and finger guards nearby and ready to go.

» Pull the template on page 145. Center the header art at the top of the canvas, leaving about a ½ inch (1.3 cm) of empty space above it. Transfer the template onto the wood using the carbon paper, pencil and tape. Refer to the Transferring Your Templates section in Chapter One (page 13) for details. Once you've finished, remove the template and carbon paper, and make sure you didn't miss any lines.

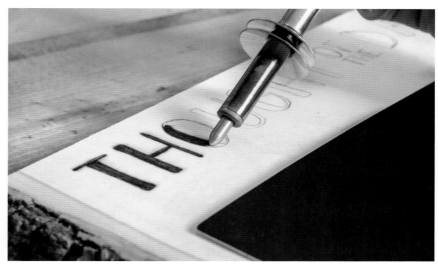

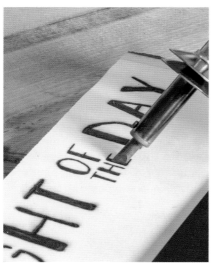

STEP TWO: MEASURING YOUR CHALKBOARD SHEET AND BURNING THE LETTERS

» It was difficult to find a live-edge canvas that a chalk sheet fit onto perfectly, but cutting the sheet to fit isn't difficult. Before burning your artwork, use chalk and a ruler to measure your chalkboard sheet and cut off any excess that doesn't fit the board. You'll apply the resized sheet in step three.

» Now that your burner is nice and hot, start burning the large wavy-edged letters first. They are thin enough that you don't have to outline each letter first. Just tilt your burner slightly and let the round tip 2 flow along the surface of the wood, filling in each letter.

» After you've burned all your large letters, turn off your burner and let it cool. Switch the tip to the straight edge tip. Turn your burner back on and set the heat to low-medium. If you don't have heat settings on your burner, try lightly blowing on the tip of your burner or holding it in front of your fan to lower the heat.

» Start burning the small letters. Follow the carbon lines on the wood with the tip of your burner and work slowly and carefully, paying attention to the small, narrow lines of the letters. The small letters will burn quickly with the straight edge tip. They're so small that there is no need to fill them in separately.

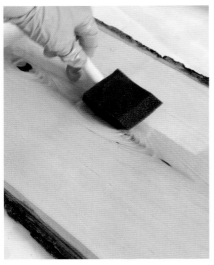

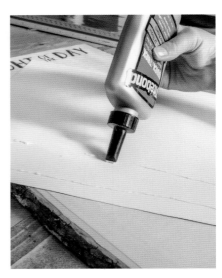

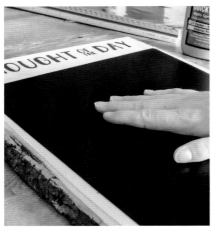

STEP THREE: VARNISHING AND ADDING THE CHALKBOARD SHEET

» Grab your gloves, sponge brush and Danish oil. If you are varnishing the board in an area that you want to protect from drips and spills, put down a couple layers of craft paper or cardboard for protection.

» Pour a small amount of the varnish over the wood and into the sponge brush. Spread the varnish all over the wood, covering every inch, front and back—including the live edge. This will seal and protect the wood from moisture. Allow the varnish to dry according to the manufacturer's directions. Since this piece will be hanging inside, one coat will be sufficient.

» Grab the chalkboard sheet you prepared in step two. Add glue all over the back of the sheet and place it on the canvas below your header, making sure to align the edges.

Tip

If you can't find chalkboard sheets, try adding chalkboard paint to your canvas instead. Use painter's tape to tape off the area for the chalkboard, and then fill it in with the paint. Give it two coats to ensure good coverage.

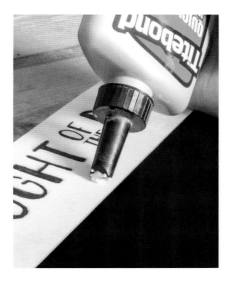 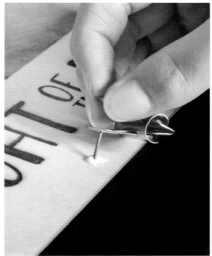 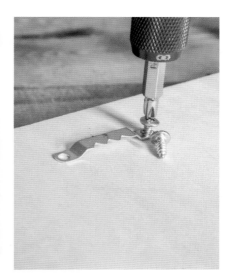

Tip

The copper bulldog pushpin clip was challenging to push in because of the gap between the tabs. I found that putting something like an eraser between the tab to close the gap made it easier to push the pin into the wood.

STEP FOUR: ADDING THE COPPER CLIP AND THE HANGER

» Center the bulldog pushpin clip above the chalkboard sheet and slightly push the pin into the wood to make a small indention. Place a small amount of glue over the mark. The glue will help the clip attach to the wood and prevent it from wiggling. You want enough glue to hold the hanger in place, but not so much that a lot of excess is left.

» After you apply the glue to the canvas, place the pin of the clip back into the indention and push it all the way in. These pushpin clips are tough to push in, but you can't use a hammer because it will warp the clip. I've found using a Phillips head screwdriver helps push the nails all the way in.

» Grab your sawtooth hanger to attach to the back of the sign. Make sure the hanger you use has the capacity to hold the sign. The one I used was rated to hold 25 pounds (11 kg). Center the sawtooth hanger on the back of the sign and secure it in place with screws.

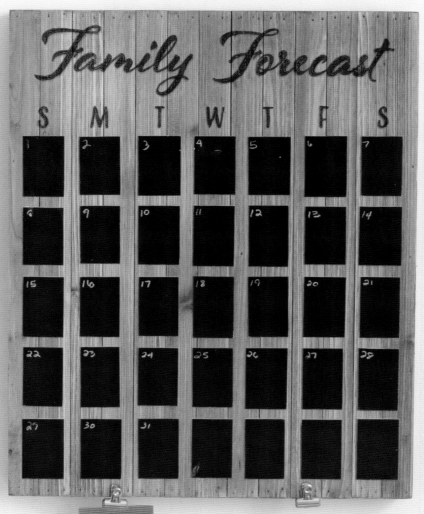

Family Forecast

S	M	T	W	T	F	S
1	2	3	4	5	6	7
8	9	10	11	12	13	14
15	16	17	18	19	20	21
22	23	24	25	26	27	28
29	30	31				

8:30
Soccer

CHALKBOARD TILE
Calendar

This chalkboard calendar is one of the more complex crafts in the book—mostly because there are a lot of steps. The woodburning itself is a simple lettering design, but the chalkboard tiles that make up the calendar have to be measured, cut and placed in rows and columns. You also need to make sure you find the right size canvas to ensure the tiles will all fit. There are a lot of moving parts for this project, but I'll walk you through each one.

In the end, you'll have a beautiful calendar that will complement your décor much better than any drugstore calendar. You can also add little clips on the board for you to post notes or important papers that you may need to keep track of. It's a practical piece that looks good and helps the family keep their schedules together.

ABOUT THE WOOD

The canvas for this project needs to be large. All of the lettering and chalkboard tiles take up a lot of space. Pine is what I used, but the size is important. Pick a good size over wood type here. The canvas I chose has a nice color and is soft enough to burn in deep dark lettering. The wood slats with a bit of space in between add a nice rustic touch to the finished piece.

WHAT YOU'LL NEED

- 12" x 16" (30.5 x 40.5-cm) chalkboard sheet
- Ruler
- Chalk pencil
- Scissors (or paper cutter)
- Templates (see page 146)
- 20" x 24" (51 x 61-cm) wood canvas with hanger (I got mine at Hobby Lobby)
- Tape
- Woodburning tool with a round tip 1
- Safety equipment: mask, fan and finger guards
- Carbon paper
- Pencil
- Gloves
- Sponge brush
- Danish oil
- Craft paper or cardboard to protect your workspace (optional)
- Wood glue
- 2 copper bulldog pushpin clips, optional

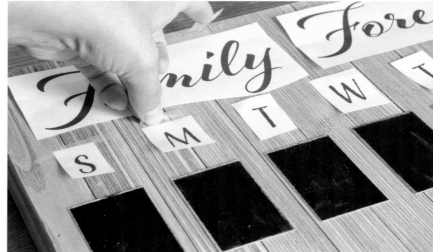

Tip

You can buy pre-cut chalkboard tiles in many craft stores. Just make sure the size will fit onto the wood canvas; trim them down if necessary. Compared to the chalkboard sheet, the precut tiles cost about four times as much as the sheet.

STEP ONE: CUTTING THE CHALKBOARD TILES AND PREPARING THE TEMPLATES

» You will need 7 columns and 5 rows of 1⅝ x 2½–inch (4 x 6.5–cm) chalkboard tiles to have enough for the calendar—35 in all. Cut the tiles from the chalkboard sheet and set them aside. Don't worry if they aren't all perfectly the same size.

» Pull the templates on page 146. Because the wood canvas is so large, you will stretch FAMILY FORECAST across the top. First, cut out the FAMILY and FORECAST pieces. Position them about an inch (2.5 cm) from the top and centered horizontally, then tape them down.

» Next, cut out each letter of the week individually. You're going to space them out on the canvas underneath FAMILY FORECAST and tape them down one at a time. I started with W for Wednesday since it is the letter in the very center. You'll want the letters centered above each row of chalkboard tiles, so you'll need to measure the placement of the tiles in order to position the rest of the letters and tape them down.

» Beginning with the Wednesday column, center the first tile horizontally in the middle of the board and leave enough room at the top for the day of the week letter. DON'T GLUE THE TILES DOWN YET. You are just tentatively placing the tiles in order to position the day of the week letters for transferring. On either side of the center tile, place three tiles about ½ inch (1.3 cm) apart from each other to establish the other six columns.

» Now you can start placing all of your day of the week letters about 1½ inches (4 cm) above the tiles and tape them down. Then, you can remove the tiles from the board and set them aside.

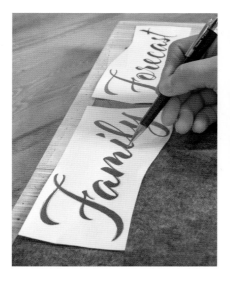

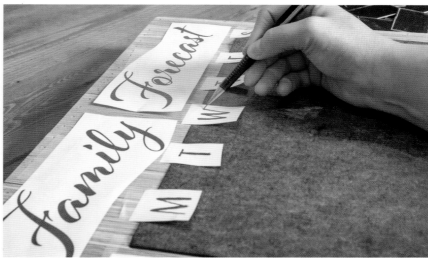

Tip

If you're using a canvas with a built-in hanger, make sure you're burning it with the right side up when you flip it over.

STEP TWO: SETTING UP AND TRANSFERRING THE ARTWORK

» Put a round tip 1 in your burner. Turn on your burner to medium and let it preheat while you set up your canvas in your workspace. You will be burning small lines in this project, and working with less heat will allow you to work at a slower pace and control the burner more easily.

» If your burner doesn't have heat settings, the default heat setting is likely too hot to achieve the best results. However, you can use your fan to temporarily cool the tip of the burner so it doesn't scorch your wood. You may have to place the tip in front of your fan several times throughout the burning process, especially when you're burning some of the smaller lines.

» As we discussed in Chapter One, safety equipment is important. Have your mask, fan and finger guards nearby and ready to go.

» Transfer the templates you positioned in step one onto the wood using the carbon paper, pencil and tape. Refer to the Transferring Your Templates section in Chapter One (page 13) for details. Once you've finished, remove the templates and carbon paper, and make sure you didn't miss any lines.

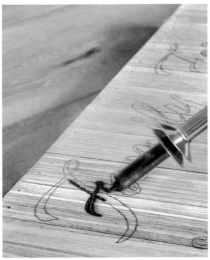

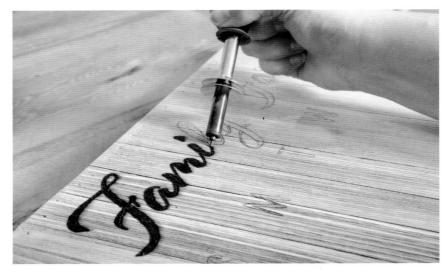

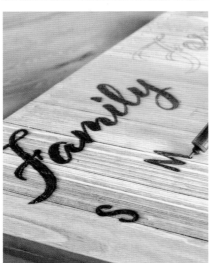

STEP THREE: BURNING THE LETTERS AND VARNISHING

» Now that your burner is nice and hot, you can start burning the FAMILY FORECAST letters. Follow the carbon lines on the wood, outlining and filling in each letter as you go.

» After you've filled in FAMILY FORECAST, move on to filling in the letters for the days of the week. They are thin enough that just tracing inside the carbon lines will fill them in pretty quickly.

» Grab your gloves, sponge brush and Danish oil. If you are varnishing the board in an area that you want to protect from drips and spills, put down a couple layers of craft paper or cardboard for protection.

» Load your sponge brush with varnish and spread it all over the wood, covering every inch, front and back. Allow the varnish to dry according to the manufacturer's directions. Once the first coat is dry, apply a second coat of Danish oil for added protection.

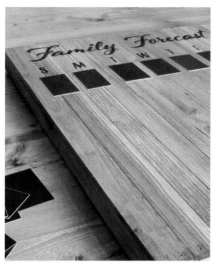

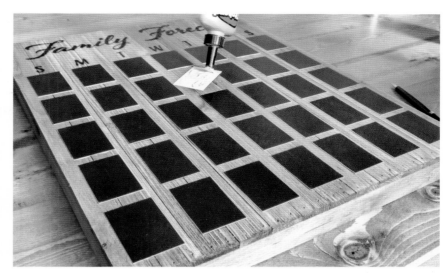

STEP FOUR: GLUING THE TILES AND ADDING OPTIONAL COPPER CLIPS

» After your board is completely dry, move on to gluing down the tiles. This is where things get exciting!

» There will be 7 columns and 5 rows of tiles. Measure from the center outward again to place the tiles, just like we did in step one. You'll want to make sure they are centered and aligned properly before gluing them down.

» Center the first tile in the Wednesday column, and then continue to center the remaining 6 tiles in the row. Now place the 4 other tiles in the Wednesday column, centering them vertically.

» Place the remaining rows of tiles, one at a time, adjusting the spacing as you work your way across the board.

» After all the tiles are in position, pick up each one, add glue to the back and adhere them to the canvas. I like to start in the middle and work my way out to help prevent spacing and alignment problems. Once you've glued down all the tiles, let them dry.

» You can add a couple of clips at the bottom of the calendar to keep track of important notes and papers. I used leftover copper bulldog pushpin clips from the Thought of the Day Chalkboard project (page 85).

» Measure where you'll add the clips and add a drop of glue to each spot. The glue will help the clip attach to the wood and prevent it from wiggling. You want enough glue to hold the hanger in place, but not so much that a lot of excess is left. Once you push the pins into the wood, you're ready to hang up the calendar and add your dates and events.

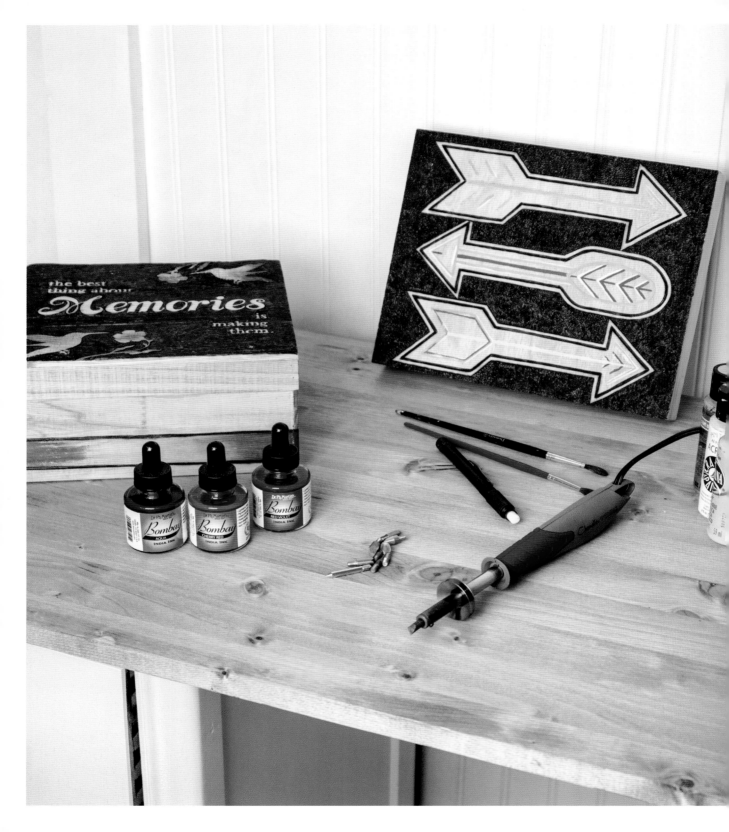

Five

ADDING COLOR

Adding color to pyrography projects creates yet another layer of creativity and visual interest. In this chapter, you'll examine how to incorporate color into your woodburned artwork with simple but elegant designs.

Using color on wood can be intimidating because there are so many mediums to use—oils, acrylics, inks, watercolors and more. People often ask me if they should add the color before or after they burn. It's a great question, and the first thing to consider is whether the paints being used are safe to burn. It's difficult to establish the safety of burning paints, so it's best to err on the side of caution and add the color after you burn. The risk isn't worth it.

When it comes to adding color, simplicity is key. The pyrography is the star of the piece, but color can enhance the focal point. The projects in this chapter were specifically designed to help you ease into using inks and acrylic craft paint to enhance your work and practice with color.

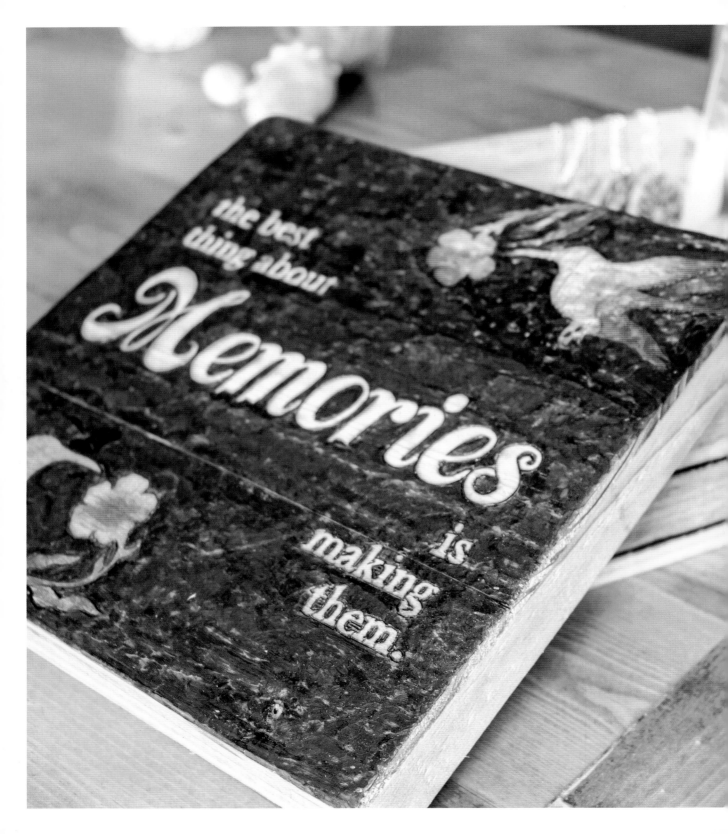

Keepsake Box WITH INK

The pine wood for these boxes is particularly soft and porous, making it an ideal option for a reverse burn with ink. The softness of the wood makes it easier to burn a large area quickly, and the porousness of the wood will ensure it soaks up the water and ink really well.

Adding ink is the easiest way to enhance your pyrography with simple coloring. If you want to add shades and details, acrylics are better, but inks are also a great option for solid colors. I use ink regularly in my pieces to add in a pop of color without overpowering the designs I've burned. Don't worry too much if you aren't experienced with painting. The method I cover here is a quick and fun way to add color.

ABOUT THE WOOD

Wood boxes come in all different shapes and sizes in the arts and crafts aisle. I chose this pine box because it has a nice medium size. There's enough room to keep small important items like jewelry and cards.

WHAT YOU'LL NEED

- Woodburning tool with a round tip 1, a flat shading tip and a straight edge tip
- Safety equipment: mask, fan and finger guards
- Template (see page 150)
- Scissors
- 8" x 8" (20.5 x 20.5–cm) wood box (I got mine at Hobby Lobby)
- Carbon paper
- Pencil
- Tape
- Paintbrush
- Water for cleaning your brush and wetting the wood
- Artist ink
- Ruler
- Gloves
- Sponge brush
- Danish oil
- Craft paper or cardboard to protect your workspace (optional)

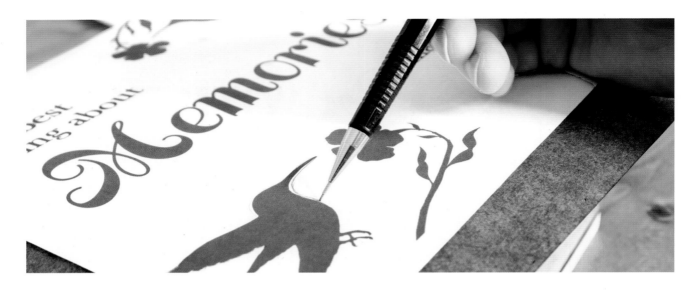

Tip

Sand the box first, before you transfer the template. These premade boxes can have a lot of rough spots and splintering. Sanding it down first will give you a smooth surface to trace and burn.

STEP ONE: SETTING UP AND TRANSFERRING THE ARTWORK

» Put a round tip 1 in your burner. Turn on your burner to medium and let it preheat while you set up your canvas in your workspace.

» If your burner doesn't have heat settings, the default heat setting is likely too hot to achieve the best results. However, you can use your fan to temporarily cool the tip of the burner so it doesn't scorch your wood. You may have to place the tip in front of your fan several times throughout the burning process, especially when you're burning some of the smaller lines.

» As we discussed in Chapter One, safety equipment is important. Have your mask, fan and finger guards nearby and ready to go

» Pull the template on page 150 and cut it down to size. Center the artwork as best you can on the box and transfer the template onto the wood using the carbon paper, pencil and tape. Refer to the Transferring Your Templates section in Chapter One (page 13) for details. Once you've finished, remove the template and carbon paper, and make sure you didn't miss any lines.

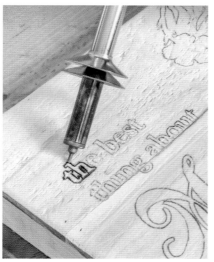

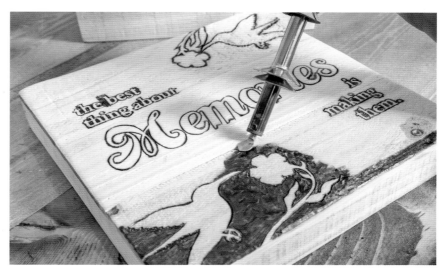

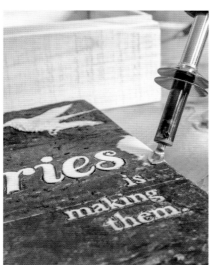

STEP TWO: OUTLINING WITH A REVERSE BURN AND FILLING IN

» Once the artwork is transferred, start outlining the OUTSIDE of the carbon transfer lines. You are going to reverse burn this piece. The inside of the artwork will be left unburned while the background will be burnt.

» First, carefully start outlining all of the letters with the round tip. The lettering is so small, that the round tip helps get into the small curves and details of the letters.

» Once your letters are outlined, move on to the birds and flowers. Use the same technique as in the above step. Burn the outside of each carbon transfer carefully using the rounded burner tip.

» After you've finished burning the outlines, turn off your burner and let it cool. Switch the tip to the flat shading tip. Turn your burner back on and let it heat up to medium heat.

» Once the burner is heated up again, use the flat shading tip to fill in the rest of the background with burn. When you get close to the outlines of the letters and artwork, make sure to go slow. You don't want to accidentally burn the inside of your lettering or artwork.

» When you turn your burner off again, let it cool completely and replace the flat shading tip with the straight edge tip.

STEP THREE: ADDING INK TO THE TOP

» Use any color of ink that excites you to add color to the birds and flowers. I used a pinkish red and purply blue.

» The first thing to do is wet the wood area where you'll be adding the ink. Start with the bird and simply add a few drops of ink to the wet area and let the color spread naturally. Add the pinkish red to the left side of the bird and let it gently spread so that the color gradually fades on the right side. If you need to add more water to make the ink spread, go for it. Use your brush to help spread the ink to areas you want it to go. You can't go wrong here. Add as much or as little color as you'd like. The goal is to just have color.

» For the flower, make sure it's still wet. If not, add more water. Then add a drop of pinkish red ink to the outside of each petal. Let the color spread into the water.

» Clean the brush before loading it with the blue ink and dropping a small dot in the center of the flower. Then add some blue ink to the stem area and let it spread, too.

» Repeat this process with the other bird and flower. Let it dry before moving on to the next step.

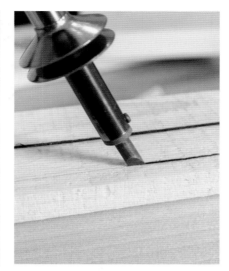

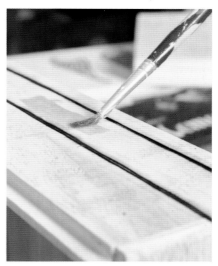

STEP FOUR: ADDING THE SIDE BURN, ADDING INK TO THE SIDES AND VARNISHING

» Burning lines on the sides of the box will help control where the color spreads when the ink is applied. The color will match the top of the box to tie it all together. Grab your ruler to draw the lines on the sides. I placed my lines in the very center of the bottom, but the placement is optional. Make sure they line up on each end so that it looks like a ribbon all the way around the box.

» After you get the lines drawn, use your straight edge tip to burn in the lines. Add two rows of lines to the top and bottom line. Doubling up will make a nice solid line.

» On the side of the box, add water to the inside of the lines to wet the wood. When the ribbon is completely wet, add pinkish red to one side and let it spread into the water. Use your brush to spread the ink. Only spread it inward, close to the center of the ribbon.

» Wash your brush. On the other side of the ribbon, spread the blue color ink close to the center. Leave a small amount of wood color exposed in the center of the ribbon. Let the ink dry and repeat the process on each side.

» Grab your gloves, sponge brush and Danish oil. If you are varnishing the box in an area that you want to protect from drips and spills, put down a couple layers of craft paper or cardboard for protection.

» Load your sponge brush with varnish and spread it all over the wood, covering every inch, inside and out. Allow the varnish to dry according to the manufacturer's directions. Once the first coat is dry, apply a second coat of Danish oil for added protection.

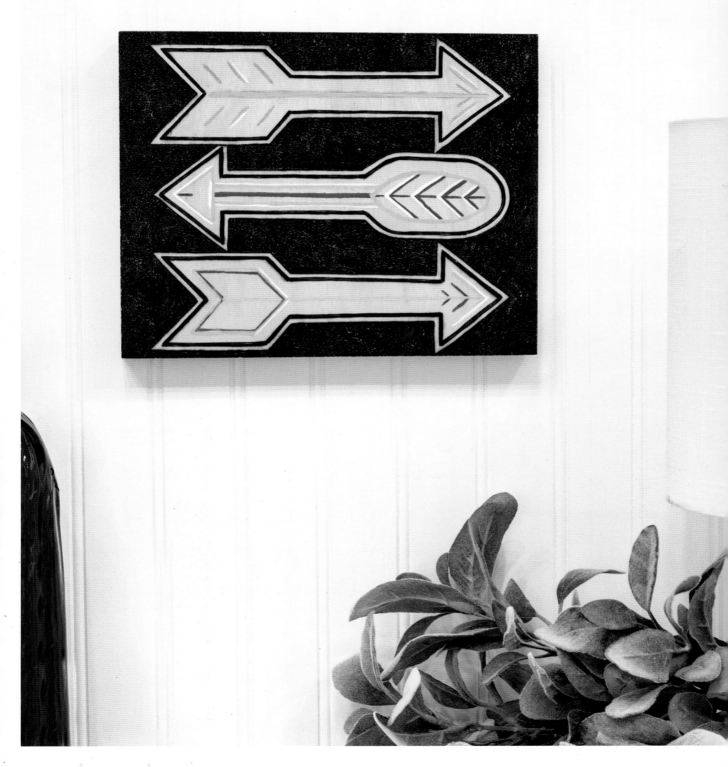

Arrow Art WITH ACRYLICS

This arrow art project is a fun piece that features acrylic paint accents. Acrylics work well on wood and can add some beautiful color variation to your pyrography. You can use any color palette you'd like, but feel free to follow along with my blues and gold.

I'm also going to be instructing you on how to create a new texture for the background. It's a basic squiggle texture that looks amazing when complete. The most challenging part about it is the time it takes to finish it. Now pick up your burner and let's get to it.

ABOUT THE WOOD

Birch wood panels have a light natural color and are perfect to use when you want to add more vibrant shades. Deep dark burns with pops of color give the overall finished piece great contrast. The arrow art pattern is all straight lines, and the consistent grain pattern of the birch canvas makes burning them super easy.

WHAT YOU'LL NEED

- Woodburning tool with a straight edge tip and a round tip 1
- Safety equipment: mask, fan and finger guards
- Template (see page 147)
- Scissors
- 8" x 10" (20.5 x 25.5–cm) birch wood canvas with cradle (I got mine on Amazon)
- Carbon paper
- Pencil
- Tape
- Acrylic craft paint
- Paint reservoir or parchment paper
- Paintbrush
- Water for cleaning your brush
- Gloves
- Sponge brush
- Danish oil
- Craft paper or cardboard to protect your workspace (optional)
- Sawtooth hanger with screws
- Phillips head screwdriver

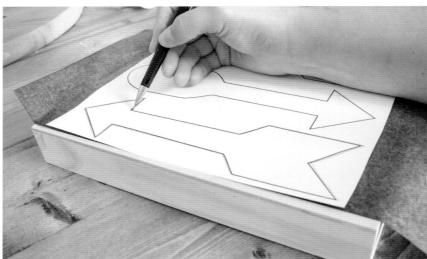

Tip

Sketch out the inside arrow art designs before painting them. That will give you a template to paint over.

STEP ONE: SETTING UP AND TRANSFERRING THE ARTWORK

» Put a straight edge tip in your burner. Turn on your burner to medium and let it preheat while you set up your canvas in your workspace.

» As we discussed in Chapter One, safety equipment is important. Have your mask, fan and finger guards nearby and ready to go.

» Pull the template on page 147 and cut it down to size. Center the artwork as best you can on the box and transfer the template onto the wood using the carbon paper, pencil and tape. Refer to the Transferring Your Templates section in Chapter One (page 13) for details. Once you've finished, remove the template and carbon paper, and make sure you didn't miss any lines.

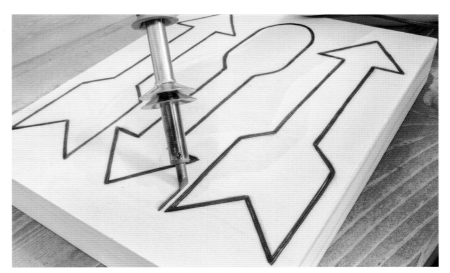

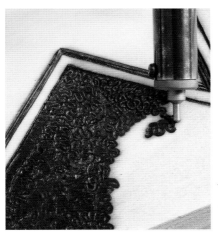

STEP TWO: OUTLINING WITH A REVERSE BURN AND BURNING AN S PATTERN

» Once the artwork is transferred, start outlining the OUTSIDE of the carbon transfer lines. You are going to reverse burn this piece. The inside of the arrows will be left unburned so we can add the paint.

» Burn 3 lines together around each arrow. That will make a nice solid line so you can burn in the background around the arrows.

» After you have all the lines burned around the arrows, turn off your burner and let it cool. Switch your tip to the round tip 1. Turn your burner back on and let it heat up to medium-high heat.

» Once your burner is hot again, you are going to burn a simple swirl pattern that will give the background a lot of great texture instead of a plain flat burn.

» Swirl your round tip on the wood's surface in a repeating S pattern until the entire background is filled. When you get close to the outlines of the arrows, make sure to go slow. You don't want to accidentally burn the inside of the design.

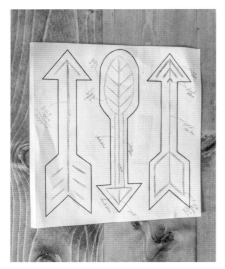 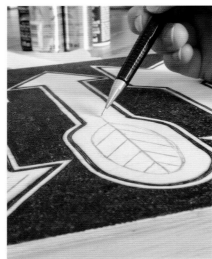 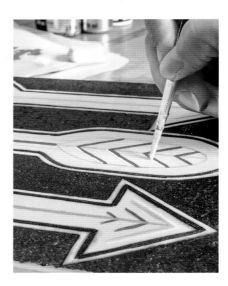

Tip

If your pencil sketches are coming through the acrylic paint, let it dry and add a second coat.

STEP THREE: ADDING THE PAINT

» Once you're finished filling in the background, it's time to add acrylic paint to the arrows to jazz up the look. I chose to use blues, gold, copper and white, but you can use whatever colors you prefer.

» Before I added my paints, I drew a sketch plan of arrow designs and where I wanted to put each color. This helped me predetermine my color pattern.

» Grab your paint reservoir or parchment paper to hold your paints. You don't need much. A dime-sized circle is plenty. Just have fun with the colors and mixing them up together. I like combing the blues for contrast and adding the gold and copper as an accent color.

» Paint thin lines over your sketches. I started with the dark blue, added light blue and then added the gold and copper accents. Once it's all dry, go back and add white for contrast.

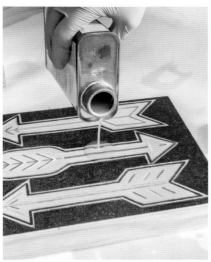

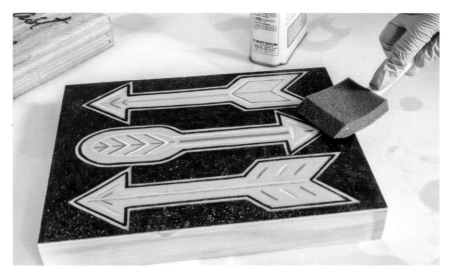

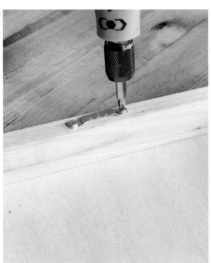

STEP FOUR: VARNISHING AND ADDING THE HANGER

» When your paint is completely dry, add the varnish. Grab your gloves, sponge brush and Danish oil. If you are varnishing the artwork in an area that you want to protect from drips and spills, put down a couple layers of craft paper or cardboard for protection.

» Load up your sponge brush with varnish and spread it all over the wood, covering every inch, front and back. This will seal and protect the wood from moisture. Allow the varnish to dry according to the manufacturer's directions. Once the first coat is dry, apply a second coat of Danish oil for added protection.

» Grab your sawtooth hanger to attach to the back of the sign. Make sure the hanger you use has the capacity to hold the sign. The one I used was rated to hold 25 pounds (11 kg). Center the sawtooth hanger on the back of the sign and secure it in place with screws.

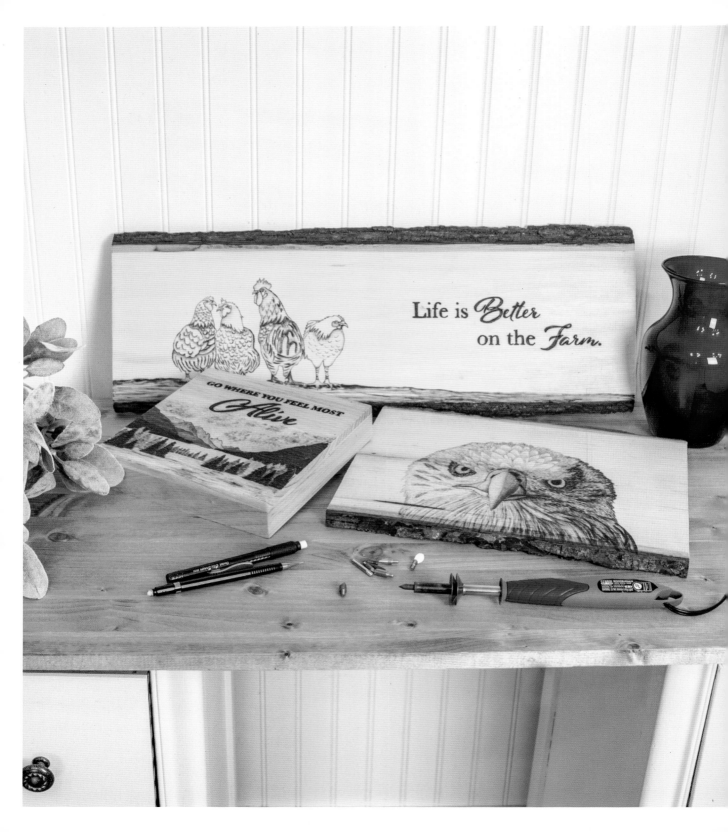

Six

BUILDING YOUR SKILLS WITH ANIMALS AND LANDSCAPES

At this point in the burning process, you've gotten familiar with your burning tool, the wood and how the heat settings affect your color. It's time to take that knowledge and put it toward more advanced burning pieces and continue to build your skills.

We'll start that off in this chapter with a simple deer silhouette pattern. Silhouettes are a perfect starting point for burning animal patterns. There are tons of inventive ways to add interesting flourishes with patterns, backgrounds and reverse burning.

Then we'll move into some projects that use shading. Shading is the key to burning more detailed and complex pieces of animal art and landscapes. The goal is to control how deep and dark you burn different shades. By controlling the amount of shade, you can accurately replicate portraits and images. Experiment with different shading techniques and find one you connect with and have the most control over.

These projects will illustrate new patterns and shading techniques. The images get more complex as you go through the chapter and by the end you will complete an eagle portrait. Grab your burner and let's get started!

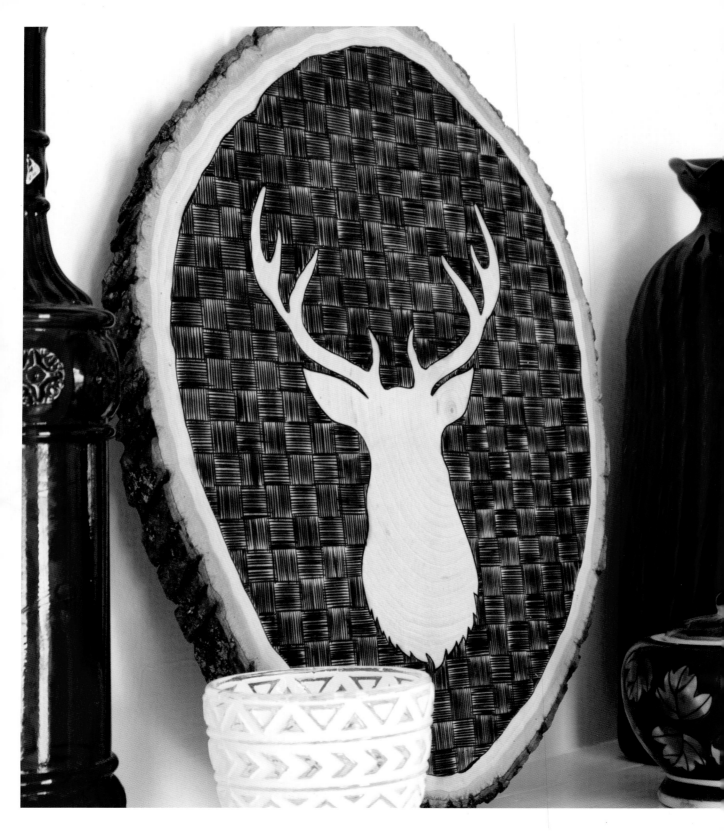

DEER SILHOUETTE
Wall Décor

This project was created specifically to illustrate a new woodburning pattern: parquet. I love this pattern because it's easy to create, adds another level of interest to a simple design and is so much fun to burn. There's not a lot of complexity to the pattern, but it's very relaxing to burn these lines in a rhythm. The deer silhouette goes perfectly with the parquet style. Plus, the rustic woodsy look of the deer design complements the live-edge wood canvas.

ABOUT THE WOOD

The basswood canvas I used in this project is nice and soft. The straight edge tip cuts through the wood like butter, creating crisp, clean lines, which makes burning the parquet pattern in the background that much easier.

WHAT YOU'LL NEED

- Woodburning tool with a straight edge tip
- Safety equipment: mask, fan and finger guards
- Template (see page 149)
- 10" x 12" (25.5 x 30.5–cm) live-edge basswood canvas (I got mine from Hobby Lobby)
- Carbon paper
- Pencil
- Tape
- Ruler
- Gloves
- Sponge brush
- Danish oil
- Craft paper or cardboard to protect your workspace (optional)
- Sawtooth hanger with screws
- Phillips head screwdriver

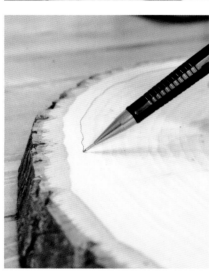

STEP ONE: SETTING UP AND TRANSFERRING THE ARTWORK

» Put a straight edge tip in your burner. Turn on your burner to medium-high and let it preheat while you set up your canvas in your workspace. You'll be burning only lines in this project, so the high heat will help you achieve clean, straight burns.

» You can still make this project even if your burner doesn't have heat settings. The default heat setting should be appropriate for burning faster and larger lines and shouldn't overpower the wood, but if your tip is too hot, you can always hold it in front of your fan for a few seconds to cool it off.

» As we discussed in Chapter One, safety equipment is important. Have your mask, fan and finger guards nearby and ready to go.

» Pull the template on page 149. Center the template as best you can and transfer it onto the wood using the carbon paper, pencil and tape. Refer to the Transferring Your Templates section in Chapter One (page 13) for details. Once you've finished, remove the template and carbon paper, and make sure you didn't miss any lines.

» Then, take your pencil and roughly draw a circle around the edge of the canvas. This will become your border where your background texture will end.

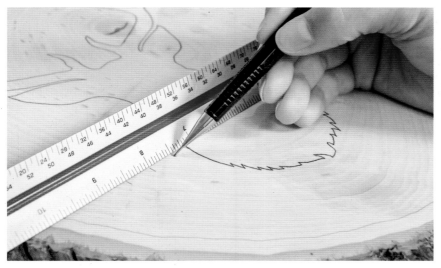

STEP TWO: ADDING THE BACKGROUND LINES

» First, use a ruler to make a grid of ½-inch (1.3-cm) squares. The squares will become the parquet background.

» Position the ruler so it spans the widest part of the wood canvas. Mark ½-inch (1.3-cm) tics across the wood in two places so you can connect them to make lines. Avoid drawing lines inside the deer.

» Once all the marks are in place, use your ruler to connect the marks and draw lines all the way down the canvas.

» Repeat the same process in the other direction to make the grid. You should have a canvas full of ½-inch (1.3-cm) squares all around the deer.

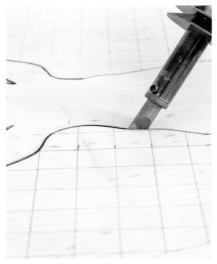

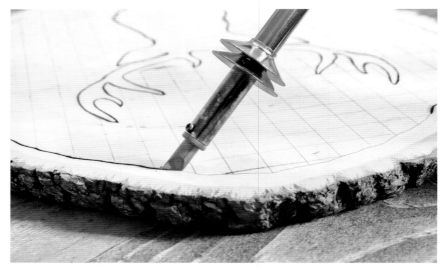

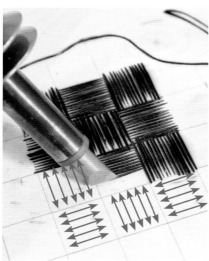

STEP THREE: OUTLINING THE ARTWORK AND BURNING THE BACKGROUND PATTERN

» Now that your burner is nice and hot, you can burn the outline of the deer. Follow the carbon lines on the wood until the whole outline is burned.

» After you've outlined your deer, burn the outer border you drew in step two.

» Now it's time to burn the parquet pattern. This is a great background for adding interest to a simple silhouette.

» Start filling the first square with straight horizontal lines all the way across. Fill the next square with vertical burn lines all the way across, and continue alternating this pattern until the canvas background is complete.

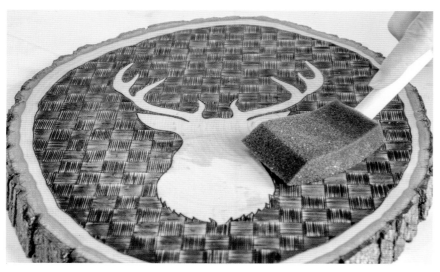

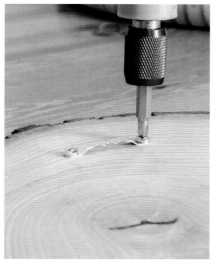

STEP FOUR: VARNISHING AND ADDING THE HANGER

» Grab your gloves, sponge brush and Danish oil. If you are varnishing the artwork in an area that you want to protect from drips and spills, put down a couple layers of craft paper or cardboard for protection.

» Load up your sponge brush with varnish and spread it all over the wood, covering every inch, front and back. Allow the varnish to dry according to the manufacturer's directions. Once the first coat is dry, apply a second coat of Danish oil for added protection.

» Grab your sawtooth hanger to attach to the back of the sign. Make sure the hanger you use has the capacity to hold the sign. The one I used was rated to hold 25 pounds (11 kg). Center the sawtooth hanger on the back of the sign and secure it in place with screws.

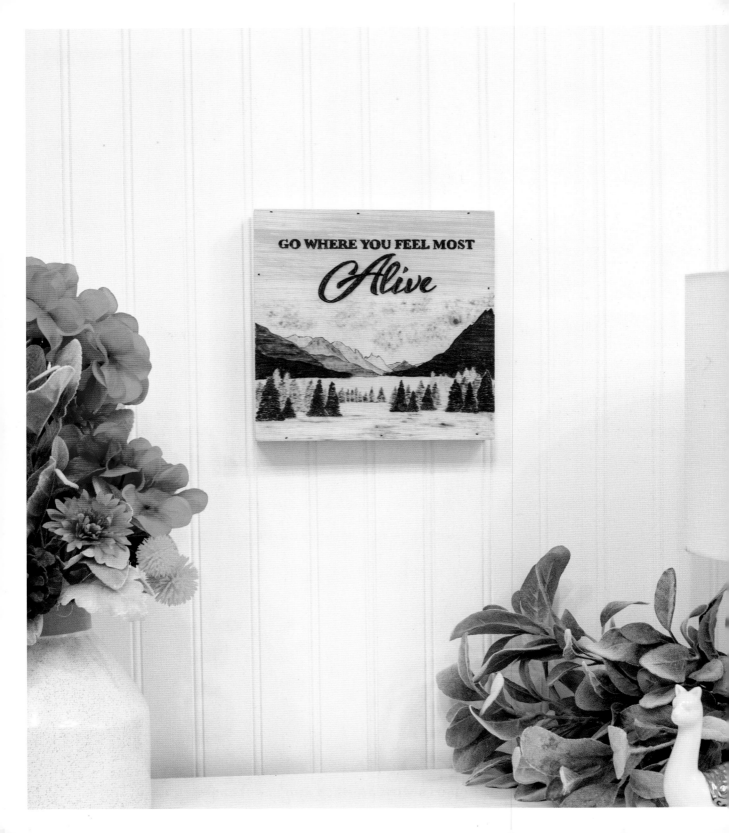

MOUNTAIN *Scene*

It's time to take a big step toward expert-level shading. For these mountains we will be creating the appearance of depth by adding dark shading to the foreground of each peak and applying lighter shades to the background. You'll repeat the same technique with the trees and ground/grass.

As I share my shading techniques in these projects, keep in mind that there is no one "right" way to accomplish something. As you work your way through this book, you will develop your own sense of style and favor certain techniques. If you develop a shading technique that differs from my examples and works better for you, by all means continue to explore that technique. There's no wrong way to shade if you end up with the finished look you wanted.

ABOUT THE WOOD

A small basswood canvas is perfect for this mountain scene. Burning the scene on a square frame creates room at the top to add in a quote. The soft wood makes it easy to burn in subtle shades to create a nice effect.

WHAT YOU'LL NEED

- Woodburning tool with a straight edge tip and a flat shading tip
- Safety equipment: mask, fan and finger guards
- Template (see page 152)
- 8" x 8" (20.5 x 20.5-cm) basswood canvas with hanger (I got mine at Hobby Lobby)
- Carbon paper
- Pencil
- Tape
- Gloves
- Sponge brush
- Danish oil
- Craft paper or cardboard to protect your workspace (optional)

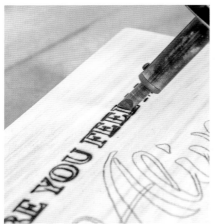

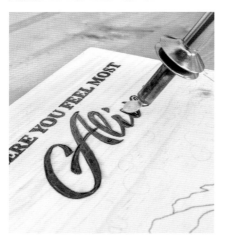

STEP ONE: SETTING UP, TRANSFERRING THE ARTWORK AND BURNING THE LETTERS

» Put a straight edge tip in your burner. Turn on your burner to medium-high and let it preheat while you set up your canvas in your workspace. You will be burning big lines in this project, so you can turn up the heat more if you want to burn at a faster pace.

» You can still make this project even if your burner doesn't have heat settings. The default heat setting should be appropriate for burning faster and larger lines, but if your tip is too hot, you can always hold it in front of your fan for a few seconds to cool it off.

» As we discussed in Chapter One, safety equipment is important. Have your mask, fan and finger guards nearby and ready to go.

» Pull the template on page 152. Center the artwork as best you can and transfer the template onto the wood using the carbon paper, pencil and tape. Refer to the Transferring Your Templates section in Chapter One (page 13) for details. Once you've finished, remove the template and carbon paper, and make sure you didn't miss any lines.

» Now that our burner is nice and hot, you can burn all the outlines of the letters. Follow the carbon lines until every letter is burned.

» After completing the outlining, turn off your burner and let it cool. Switch to the flat shading tip and turn your burner back to medium heat.

» When your burner is completely reheated, fill in all the letters. If some of your letters are thin, you can turn the flat shading tip on its side and fill in those letters using the edge of the tip.

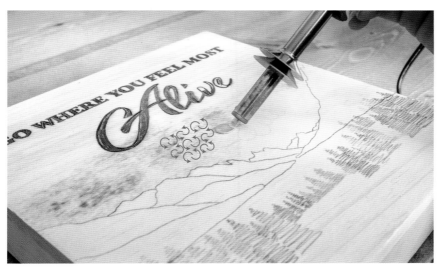
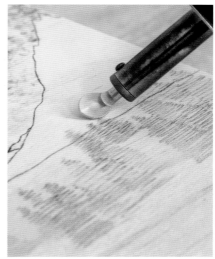

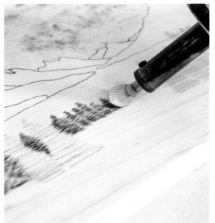

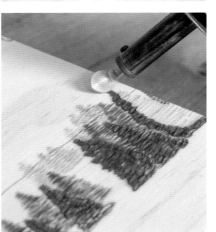

STEP TWO: BURNING THE CLOUDS AND TREES

» Still using the flat shading tip, start burning the clouds with a circular burn technique. Move the flat edge of the burner tip in a circular motion on the wood so that the tip is never sitting still on the wood's surface. By working in a constant circular motion, you can shade the wood with as much or as little burn color as you'd like.

» Burn in some light areas and dark areas that are mixed together. This will give a bit of depth and shadow to the clouds. You don't want to burn too dark—just dark enough that the clouds have some definition.

» The trees are tricky to burn. They are close together, so you want to burn them in different shades to achieve some definition.

» You're going to burn the front trees darker and the back trees lighter to create perspective. However, the motion of the tip on the wood's surface will change. Turn your shader tip on its side and move it across the wood in a zigzag motion over the tree areas to create the look of foliage. Some of the marks will be lighter and some will be darker. The difference in contrast will make the trees look like evergreens.

» Make your way through the forest creating dark burns, medium burns and lighter burns.

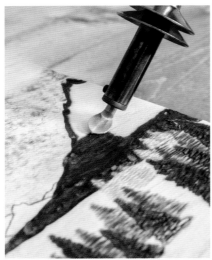

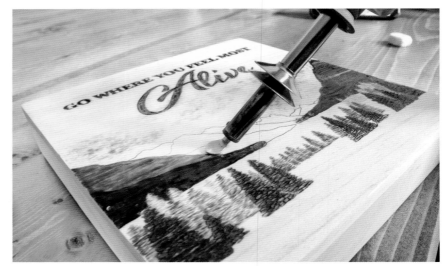

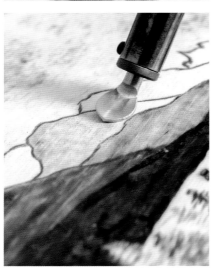

STEP THREE: BURNING THE MOUNTAINS

» Now, let's burn the mountains. Begin with the ones in the front since you'll burn these the darkest. As you burn through the mountains to the background, they will get lighter and lighter. This will help add depth to the scene. Make sure not to burn over the trees that touch the mountains.

» Still using your flat shader tip, begin filling in the mountains in the forefront with a deep dark burn by allowing the tip to linger on the wood.

» Start working your way back through all of the mountains, shading a little lighter each time. The quicker you drag your burner tip across the wood, the lighter your shading will be. You want each mountain to be a shade lighter as you go back.

» If you have a burner that has temperature settings, turn down the heat as you go to achieve lighter shades. If your burner doesn't have temperature settings, you can use a fan to cool off the tip as you're burning instead.

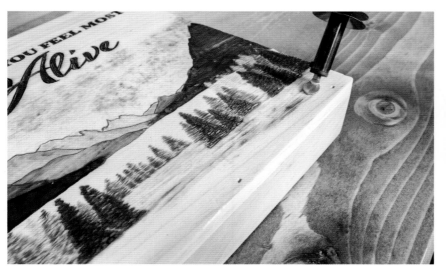

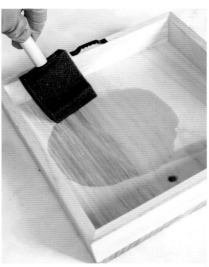

STEP FOUR: BURNING THE GROUND AND VARNISHING

» To burn the ground, drag your flat shading tip across the surface of the wood, starting out with a dark burn and transitioning to a very light shade. Go over the lines from your template to create light and dark burn lines. Continue burning the ground area until you've filled in the space.

» Grab your gloves, sponge brush and Danish oil. If you are varnishing the artwork in an area that you want to protect from drips and spills, put down a couple layers of craft paper or cardboard for protection.

» Load up your sponge brush with varnish and spread it all over the wood, covering every inch, front and back. Allow the varnish to dry according to the manufacturer's directions. Once the first coat is dry, apply a second coat of Danish oil for added protection.

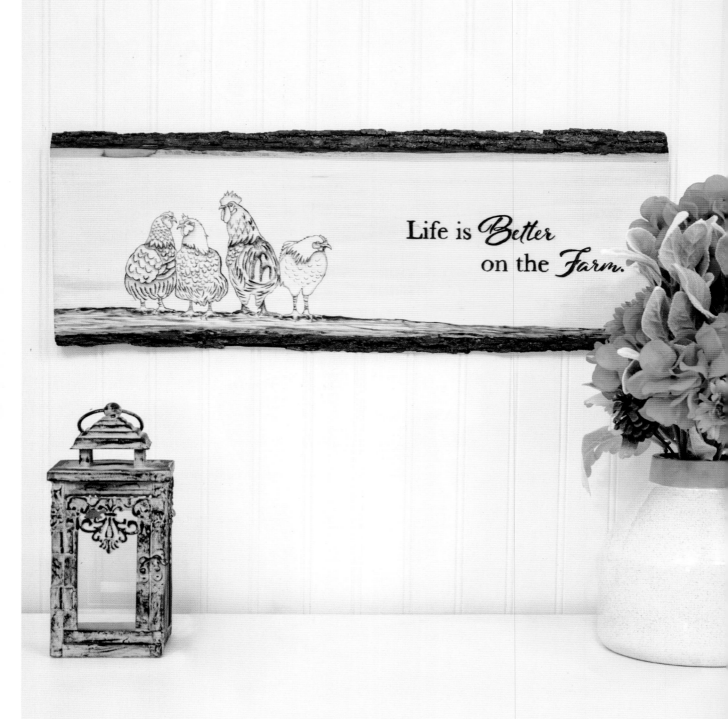

LIFE IS BETTER
on the Farm

The shading technique will be a bit different for this project because the design of the birds and branches leaves a lot of room for experimentation in shading. So, if your burn is too dark or too light, it won't affect the overall outcome of your piece.

After you've outlined the birds, you can follow my instructions to the letter, or you can play around with the shading to create something completely different. Either way, you are guaranteed to have fun with these farm birds.

ABOUT THE WOOD

I chose a basswood canvas for this project because the wood is so soft and consistent, which makes it ideal for shading. The design template for this project is long and narrow, and Walnut Hollow makes basswood canvases that are perfect for it. They come in a variety of rectangular, live-edge options. The live-edge coordinates with the rustic farmhouse theme of the artwork.

WHAT YOU'LL NEED

- Woodburning tool with a straight edge tip, a flat shading tip and a pointed tip
- Safety equipment: mask, fan and finger guards
- Templates (see page 148)
- Scissors
- 24" x 6" (61 x 15.5–cm) live-edge basswood canvas
- Carbon paper
- Pencil
- Tape
- Gloves
- Sponge brush
- Danish oil
- Craft paper or cardboard to protect your workspace (optional)
- Eyelet and wire hanger with screws
- Phillips head screwdriver

If you want to get extra creative on the setup, trace the outlines of the chickens, then use your pencil and add in your own patterns in the center. This exercise is all about learning through experimentation, so try out different feather and wing patterns.

STEP ONE: SETTING UP AND TRANSFERRING THE ARTWORK

» Put a straight edge tip in your burner. Turn on your burner to medium-high and let it preheat while you set up your canvas in your workspace. You will be burning big lines in this project, so you can turn up the heat more if you want to burn at a faster pace.

» You can still make this project even if your burner doesn't have heat settings. The default heat setting should be appropriate for burning faster and larger lines and shouldn't overpower the wood, but if your tip is too hot, you can always hold it in front of your fan for a few seconds to cool it off.

» As we discussed in Chapter One, safety equipment is important. Have your mask, fan and finger guards nearby and ready to go.

» Pull the templates from page 148 and cut them down to size. Take the chickens and place them on the left side of the canvas, and then place the quote on the right side. You'll want to vertically center the letters on the board before taping them down. Transfer the templates onto the wood using the carbon paper, pencil and tape. Refer to the Transferring Your Templates section in Chapter One (page 13) for details. Once you've finished, remove the templates and carbon paper, and make sure you didn't miss any lines.

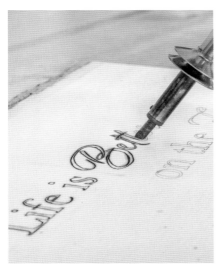

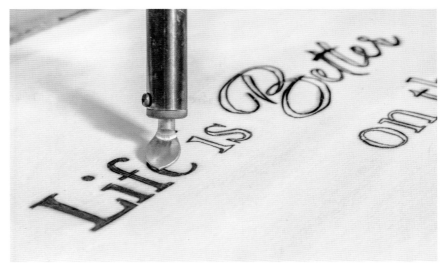

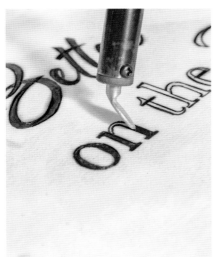

STEP TWO: BURNING THE LETTERS

» Now that your burner is nice and hot, you can burn all the outlines of the letters. Follow the carbon lines on the wood with the tip of your burner until the outline of every letter is burned.

» After you've completed all of the outlining, turn off your burner and let it cool. Switch the tip to the flat shading tip. Turn your burner back on and set the heat to medium.

» When your burner is completely reheated, fill in all the letters with a dark flat burn. If some parts of the letters are thin, you can turn the flat shading tip on its side and fill in those areas using the edge of the tip.

» After you've finished burning the lettering, turn off your burner and let it cool. Switch the tip to the pointed tip. Turn your burner back on and let it heat up to medium heat.

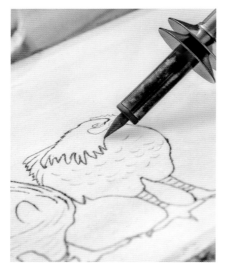

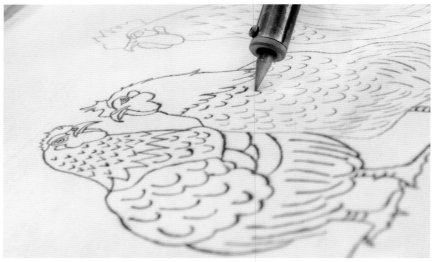

STEP THREE: BURNING THE HENS AND ROOSTER

Outlining

» Starting with the far left hen, simply burn the traced lines with the tip of your burner. Work your way across the canvas until all of the details have been outlined.

» Once you've finished burning the bird outlines, turn off your burner and let it cool. Switch the tip to the flat shading tip. Turn your burner back on and let it heat up.

Shading

» Now you'll work on shading the left two hens and rooster. You're saving the last hen for a lighter shading technique.

» Start with the far left hen. You're going to add a simple shade to each of the edges of the burned outline. Place the flat edge of your burner tip on the inside edge of each line and pull inward to create the shading.

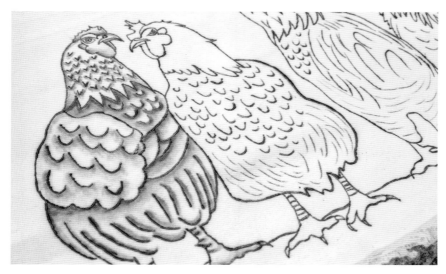

» You will use the same technique for the faces of the bird trio, adding a bit of shading around each line of the faces.

» For the feathers, add shading under each line to make them stand out. Place the flat edge of your burner tip under the feather lines and pull around each one to create a subtle shading effect. Follow this technique for three birds on the far left. You're going to try a lighter shade on the far right hen later in the instructions.

» Work on the neck areas next. We will add darker shading for contrast. Let the flat edge of your burner tip linger on the wood longer to get a darker shade. Do this for all the birds on the far left.

» For the feet, apply the same shading technique that you used for the feathers. Place the flat edge of your burner tip under each line and pull it around to create a subtle shading effect. Do this for all of the hens and the rooster.

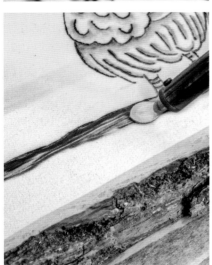

STEP FOUR: SHADING THE LAST LONELY HEN AND SHADING THE BRANCH

» You're going to try something different for the last hen. Since you've been burning darker on the other three birds, now it's time to burn lighter. It's much easier to burn dark, but it takes practice to control just the amount of burn to achieve lighter shades. By practicing on the first three, you have gained great experience with shading.

» If you have a burner with heat settings, turn it down to low. If your burner doesn't have heat settings, place the tip in front of your fan for a few seconds to cool it down.

» We are going to be using the same shading techniques from step three, however, the goal is a lighter shade. First, start with the hen's face. Place the flat edge of your burner tip on the inside edge of each facial line and pull inward to create the shading. Moving the tip quickly will help you achieve a lighter shade. Leave the head and neck white.

» Shade under the neck to give the appearance of depth.

» Finally, lightly shade under each feather line. I added a few light feather marks on the body just to give them a bit of texture.

» Now that you're done shading the hens and rooster, let's move on to the branch they are standing on. I simply used my flat shading tip and dragged it across the wood in a horizontal line pattern. You'll want to burn light lines, dark lines and medium lines. The different shades of horizontal lines will naturally mimic the texture of a tree branch.

» Now you're all finished burning!

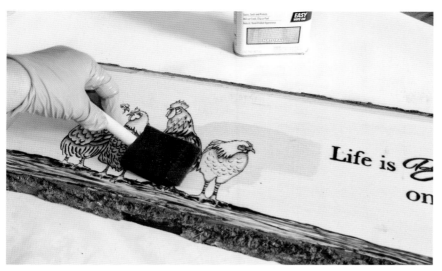

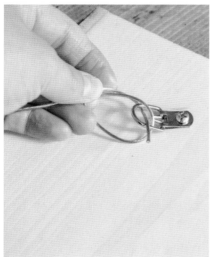

STEP FIVE: VARNISHING AND ADDING THE HANGER

» Grab your gloves, sponge brush and Danish oil. If you are varnishing the artwork in an area that you want to protect from drips and spills, put down a couple of layers of craft paper or cardboard for protection.

» Load up your sponge brush with varnish and spread it all over the wood, covering every inch, front and back. Allow the varnish to dry according to the manufacturer's directions. Once the first coat is dry, apply a second coat of Danish oil for added protection.

» Since this is a long large canvas, you'll need to add an eyelet and wire hanger. This will make it easier to hang the piece level on the wall.

» You're going to add the eyelets on the back of the canvas. The eyelets need to be placed on opposite sides of each other, about an inch from the edge of the canvas. Line them up horizontally as close as possible. It doesn't have to be perfect. The wire makes up for any unevenness on the wall.

» Once you have your eyelets in place, screw them into the canvas. Put the wire through the eyelets and secure the ends.

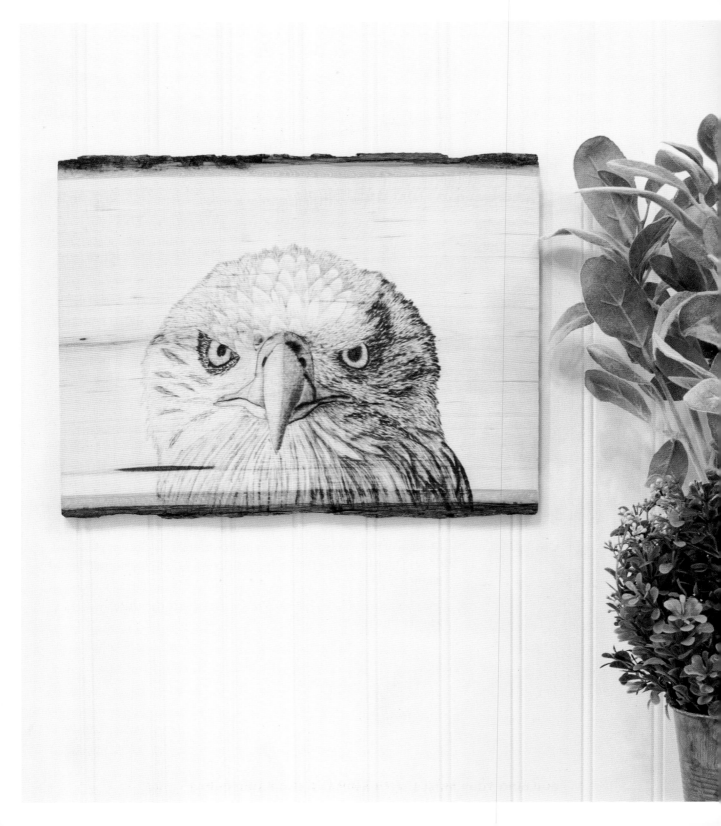

EAGLE *Eye*

This is the grand finale, folks: a portrait-style shading project. All of your practice with burning has led to this. Before you begin, try to avoid focusing on the fact that you are burning an eagle's face. It's easy to get hung up on focusing on the end result and get overwhelmed. Instead, try to perceive the face as just a series of shades. This will make replicating the face with your burner much more manageable.

Take a moment to stare at the image. Focus on all of the dark areas of the image first, then look at all of the light areas and finally at the midtones. Break apart the shading of each section, and then try to recreate those shades on the canvas. Slowly go around the image, section by section, trying to replicate each tone. Before you know it, you'll have created the image.

I'm going to walk you through the shading steps, section by section, explaining how to execute this strategy. The flat shader tip will be your best friend in this project. Get it ready and let's dive in.

WHAT YOU'LL NEED

- Woodburning tool with a flat shading tip
- Safety equipment: mask, fan and finger guards
- Template (see page 154)
- 9" x 11" (23 x 28–cm) live-edge basswood canvas
- Carbon paper
- Pencil
- Tape
- Gloves
- Sponge brush
- Danish oil
- Craft paper or cardboard to protect your workspace (optional)
- Sawtooth hanger with screws
- Phillips head screwdriver

ABOUT THE WOOD

When burning portraits, you want to choose a wood that is light and soft to make your portraits stand out. Basswood doesn't have moisture, so there won't be much bubbling when you are burning in the details.

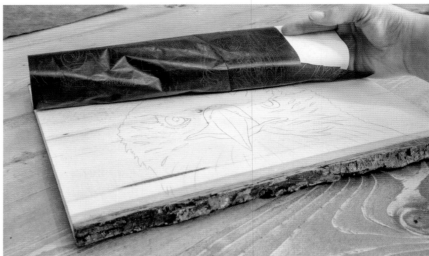

STEP ONE: SETTING UP AND TRANSFERRING THE ARTWORK

» Put the flat shading tip in your burner. Turn on your burner to medium-high and let it preheat while you set up your canvas in your workspace. You will be burning big lines in this project, so you can turn up the heat more if you want to burn at a faster pace.

» You can still make this project even if your burner doesn't have heat settings. The default heat setting should be appropriate for burning faster and larger lines and shouldn't overpower the wood, but if your tip is too hot, you can always hold it in front of your fan for a few seconds to cool it off.

» As we discussed in Chapter One, safety equipment is important. Have your mask, fan and finger guards nearby and ready to go.

» Pull the template on page 154. Center the artwork horizontally so it extends all the way down to the bottom of the canvas and transfer the template onto the wood using the carbon paper, pencil and tape. Refer to the Transferring Your Templates section in Chapter One (page 13) for details. Once you've finished, remove the template and carbon paper, and make sure you didn't miss any lines.

STEP TWO: BURNING THE BEAK, EYES AND FEATHERING AROUND THE EYE

» First, start with the beak. Outline the entire beak using the side edge of the flat shading tip. You can turn the burner tip on its side to do this.

» Begin shading the large beak area. Add darker shading to the right side of the beak by moving the flat edge of your burner tip in a circular motion across the top of the wood. Allowing the tip to linger on the wood longer will create a darker look. Use the same circular motion technique on the left side, but move the burner tip more quickly across the wood to create a lighter shade.

» To fill in the outer area of the beak, continue burning the wood with the circular motion technique. Create a darker burn on the right side and a light shade on the left side. Fill in the nose holes with a dark black burn.

» Work on the eyes next. You'll outline each eye with the tip of your burner. Fill in the center of the eye with a dark burn. The inside iris of the eye is made up of different shades of straight lines that go all the way around the circle. Quickly pull the tip of your burner across the wood from the outside edge of the iris toward the inside of the black pupil. Then use the same technique to work in the opposite direction and pull the burner tip from the pupil toward the outside edge of the iris. Repeat this method all the way around the eye.

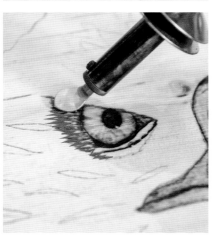

» Now add the feathering around the eye using the edge of the flat shading tip. For the darker outer edge of the eye ring, turn the burner tip on its side and use a quick side-to-side motion. Use this side-to-side motion to fill in the rest of the area around the eye.

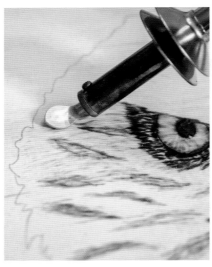
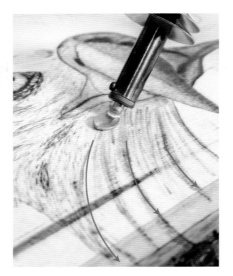

STEP THREE: FEATHERING AROUND THE FACE AND SHADING THE TOP OF THE HEAD

» Next, move on to the left side of the face with a similar feathering effect. You'll shade dark patches inside the carbon lines in that area. The rest of the area will be filled in with a light shade. Use the same side-to-side motion to create the appearance of feathers.

» In the bottom neck area, we will use a simple pulling motion to make longer feathers. Keep your shading consistent as you work with a darker shade on the right and a lighter shade on the left.

» Pull your flat shading tip down the surface of the wood. Follow the template's slightly rounded vertical lines. Create a mix of light shades and slightly darker shades for depth. As you work your way across the neck, leave your burner on the wood longer and longer to create a visual transition from light to dark.

» For the right side of the head, you'll use the same feathering technique that you used on the left side, except you will shade a darker version. Use the up and down motion to create a darker feathering effect. This will create the appearance of light coming from the left, casting a shadow on the right side.

» For the next section of shading, we'll start with the feathers on the top of the head. First, use the edge of the flat shading tip to add a shaded outline to each feather. After you shade each outline, go back and work in a circular motion across the wood's surface behind each feather to add some depth.

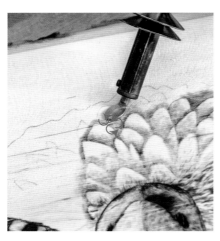

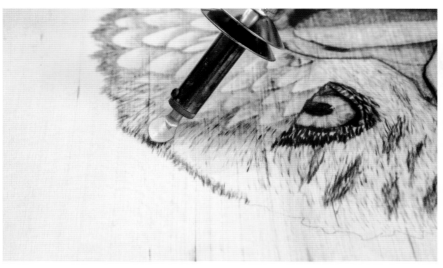

STEP FOUR: FEATHERING THE TOP OF THE HEAD, VARNISHING AND ADDING THE HANGER

» Finally, use the same feathering effect as the sides of the face to fill in the top of the head, covering your carbon lines and filling in the empty space.

» Once you've finished burning all of the sections of the bird, take a step back and take a look at the piece as a whole. Look for any areas that may need touch-ups or more shading. Make any adjustments with your burner.

» Grab your gloves, sponge brush and Danish oil. If you are varnishing the artwork in an area that you want to protect from drips and spills, put down a couple layers of craft paper or cardboard for protection.

» Load up your sponge brush with varnish and spread it all over the wood, covering every inch, front and back. Allow the varnish to dry according to the manufacturer's directions. Once the first coat is dry, apply a second coat of Danish oil for added protection. Your masterpiece is complete!

» For the back hanger, I'm using a sawtooth hanger kit with two screws. This particular sawtooth set is rated to hold 25 pounds (11 kg), so make sure the hanger you use has the capacity to hold the sign.

Seven

TEMPLATES

All of the templates for the projects can be found in this chapter. You can cut them out or you can make a copy, keeping the originals in the book to use over and over.

MAKING YOUR OWN TEMPLATES

This book is filled with template designs that are perfect for beginners. However, there will likely be times when you will want to create your own. The Wedding Gift Picture Frames (page 31) are just one great example of how personalized templates can turn your woodburning projects into cherished keepsakes.

WHAT YOU'LL NEED

- Computer
- Printer
- Paper

The trick to creating personalized templates is learning how to scale them to fit perfectly within the area you'll be burning on your wood canvas. Let's use the Wedding Gift Picture Frames (page 31) as an example.

First, you will need to measure the size of the canvas you are burning. In this case, the top portion of the picture frame measures 10½ inches (26.5 cm) wide x 2½ inches (6.5 cm) tall. Using a computer program with basic design tools, such as Paint, Photoshop or Microsoft Word, either create a new document in that exact size or draw a rectangle on the screen that fits those exact dimensions. Utilize the margin rulers to ensure the sizing is accurate.

Now you have the perfect space to fill in with the text you want to burn.

Choose a font that you like and resize the words to fit the space you created. Make sure to leave room on all four sides. You don't want the letters so large that they crowd the edges of your canvas.

After you've finished designing your template, print it out.

It's that simple. Now you have a personalized template that you can add to your pyrography pieces.

For a brief explanation of how to transfer the template onto your canvas, refer to the Transferring Your Templates section in Chapter One (page 13).

WELCOME

to our beautiful chaos,

BE
Stronger
THAN YOUR
EXCUSES

BE THE
REASON
SOMEONE
Smiles
TODAY

STRIVE FOR
Progress
NOT
Perfection

Today,
I WILL NOT
STRESS OVER THINGS
I CAN'T CONTROL.

Every

FAMILY

has a

story

Welcome to
OURS

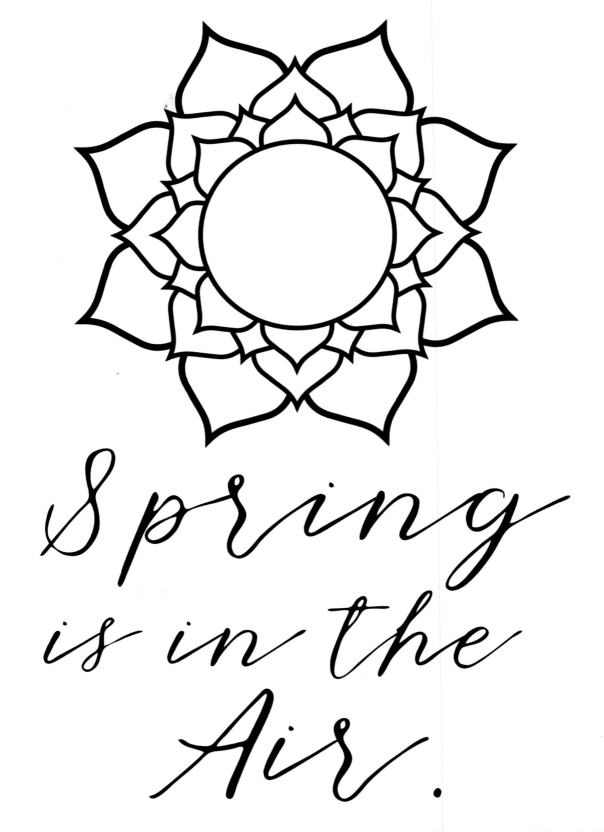

Spring
is in the
Air.

THOUGHT OF THE DAY

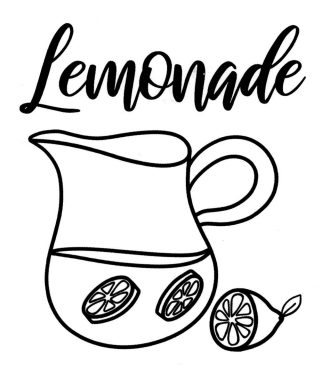

Lemonade

Family
Forecast

S M T W T F S

TEMPLATES 147

Life is *Better* on the *Farm.*

the best
thing about

Memories

is

making
them

Aa Bb Cc Dd Ee Ff Gg Hh
Ii Jj Kk Ll Mm Nn Oo
Pp Qq Rr Ss Tt Uu Vv
Ww Xx Yy Zz
1 2 3 4 5 6 7 8 9 0

GO WHERE YOU FEEL MOST

Alive

THANKSGIVING

Happy

ACKNOWLEDGMENTS

I want to give a giant heaping thank you to the best people I know, my husband and my daughter. I spent a lot of time away from them to focus on this book. They were patient with me as I worked. They gave me space and time. They helped me with art, writing and moral support when I struggled. I am extremely grateful.

I want to give a special thanks to Kristin Dillensnyder, who helped me and supported me in my early journey with this book. I wouldn't have been able to start it without her help.

Writing this book has been an extraordinary experience. The publisher and editors at Page Street believe in what I do and gave me the opportunity to put it in print. I'm shocked and grateful every day that I have been afforded this chance.

For Sharon Bowers, who helped me through this book deal, I can't say thank you enough. As a newbie to the book industry, I didn't know how to navigate the legal details, but she advised me every step of the way. Thank you so much.

ABOUT THE AUTHOR

We've all had a moment in our lives when we've discovered something that just made sense. Something that excited us and stoked our souls for creating—perhaps the feeling of a purpose fulfilled. Aney Carver knows all about that moment and the need for people to grab hold of those feelings and make the most of them.

After years of perfecting different mediums of art, Aney found her niche in pyrography and now has a flourishing business called Pyrocrafters. From creating one-of-a-kind portraits to custom signs, Pyrocrafters has piqued the interest of millions of viral video seekers on various social media platforms. Pyrography is now at the forefront of her life, and as an award-winning pyrographer, she is excited to share the art form and teach others how to get started.

INDEX